Just What the Doctor Disordered

"Quick, Henry, the Flit!"

Just What the Doctor Disordered

Early Writings and Cartoons of
Dr. Seuss

Edited and with an Introduction by
Rick Marschall

DOVER PUBLICATIONS, INC.
MINEOLA, NEW YORK

Dedicated to the Memory of Norman Anthony

Bibliographical Note

This Dover edition, first published in 2012, is an unabridged republication of the work originally published by William Morrow and Company, Inc., New York, in 1987 under the title and subtitle *The Tough Coughs As He Ploughs the Dough: Early Writings and Cartoons by Dr. Seuss.*

Library of Congress Cataloging-in-Publication Data

Seuss, Dr.
 [Tough coughs as he ploughs the dough]
 Just what the doctor disordered : early writings and cartoons of Dr. Seuss / Dr. Seuss ; edited and with an introduction by Rick Marschall. — Dover ed.
 p. cm.
 ISBN-13: 978-0-486-49846-1
 ISBN-10: 0-486-49846-8
 1. American wit and humor. 2. American wit and humor, Pictorial. I. Marschall, Richard. II.Title.

PS3513.E2T68 2012
814'.52—dc23

2012022093

Manufactured in the United States by Courier Corporation
49846801
www.doverpublications.com

Contents

Introduction by Rick Marschall . **9**

The Essays of Theophrastus Seuss . **15**

 Famous Presidential Campaigns . **17**
 How I Spied On General Grant in '61 . **18**
 The Origin of Contract Bridge . **20**
 The Clock Strikes 13! . **22**
 Hooeyana: A Reverie . **24**
 The Cutting of the Wedding Cnouth . **26**
 A Gentleman in the Case . **27**
 Sex and the Sea God . **29**
 Doing England on Ninety Cents . **31**
 The Waiting Room at Dang-Dang . **33**
 The Harassing of Habbakuk . **34**
 The Facts of Life . **36**
 Quality . **49**

Dr. Seuss's Little Educational Charts . **55**

Boids and Beasties: Piscozooavistical Surveys . **91**

Dr. Seuss's Cartoon Collection . **111**

Quick, Henry, the Flit! . **135**

Introduction by Rick Marschall
Just What the Doctor Disordered

KINDLY VISITOR—*I'd like to see Convict 515, please, if he's in.*

The essays and cartoons in these pages may well startle, as well as tickle, your funnybone. They are a forgotten output by an American icon, Dr. Seuss, produced 50 to 60 years ago by a creative talent still active in the 1980s. But more, they form a body of absurd, sometimes surreal humor of genuine originality and quality.

Dr. Seuss, whether engaging in parody, satire, or wordplay, begs our pardon in these pieces. He addresses people concerned with dignified and possibly important pursuits, and he holds up a mirror. Suddenly our habits and customs seem silly; our perceptions are less sure; our very speech patterns are challenged. We laugh because Dr. Seuss uses these pieces to reveal a comically distorted vision. Or is it superbly close to truth?

These early nonsense pieces illustrate beautifully the hoary phrase about fine lines between lunacy (let

us genuflect before Dr. Seuss's inspired brand) and genius; fine lines, yes , and broad ones, pen and brush—but all dipped in some sort of magic ink.

Dr. Seuss, essayist and cartoonist, never really engaged in revolutions of comic style and technique as much as he merrily dismantled all of such, as popular-culture critic Donald Phelps has noted about the small band of screwball artists contemporary to Dr. Seuss. Not everyone could combine what Phelps has identified as careening insouciance steeped in daffiness with authentic invention. The good

"Mr. Elman, you fool, you're off the key!"

"There, there, Professor Bach, don't fly off the Handel."

Three of Theodor Seuss Geisel's cartoons for the *Jack O' Lantern*, Dartmouth's humor magazine, 1924 and 1925.

"Kiss me."
"Whaddaya think this is—a taxi?"

doctor did so, however, and he was at the head of his class.

If there was a Golden Age in that obscure corner of journalistic history called college humor magazines, the 1920s was that era. It was a time when every major campus simply had to have its own version of the venerable *Harvard Lampoon*. *Life* magazine—itself founded in 1883 by original founders of the *Lampoon*—reprinted jokes, poems, and cartoons from the college funny papers, and *Judge*, the humorous weekly, occasionally gave over entire issues to the undergraduate wits. A major national monthly, *College Humor*, rose out of the scissors-and-gluepot gleanings of the new campus magazines.

Besides the *Lampoon*, there was the *Brown Jug*, the Williams *Purple Cow*, the *Cornell Widow*, the *Michigan Gargoyle*, the *Columbia Jester*, the *Princeton Tiger*, the *Yale Record*, the California *Pelican*, the Ohio State *Sun Dial*, and the *Virginia Reel*. Smaller schools turned out their own, including the De Pauw *Yellow*

Crab, the *Colorado Dodo*, the Colby *White Mule*, and the *Alabama Rammer-Jammer*.

The humor in many of these papers was, predictably and appropriately, sophomoric; but on the other hand many of the 1920s' brilliant crop of humorists and cartoonists were graduates of college humor magazines. Robert Benchley had drawn cartoons for the *Harvard Lampoon*, where Gluyas Williams was his editor; when they sorted out their roles each man helped significantly to define new trends in American humor. James Thurber drew his dogs for the *Sun Dial*, Bennett Cerf edited the *Jester*, Cole Porter and Peter Arno were quite professional in the pages of the *Yale Record*, and S. J. Perelman attracted wide attention—and imitators—with his inspired nonsense cartoons for the *Brown Jug*.

There was also the *Dartmouth Jack-O'-Lantern*, and there was a student named Theodor Seuss Geisel. He made a mark, signing early cartoons "TG." In perfect tune with the nonsense of his work, he appropriated a doctorate years ahead of schedule and fastened it onto his middle name (his mother's maiden name). Soon the cartoons of Dr. Seuss were delighting not only fellow Dartmouth students, but readers throughout the nation. They featured bizarre character types, outrageous puns, and corny captions. But, as with his young contemporary Perelman at Brown, Seuss's humor was distinguished for being intentionally silly— parodies of older cartoons, satires on current fads, and frequently of a self-deprecating flavor.

The cartoons, irreverent and iconoclastic, fit perfectly into the mood of the 1920s. One of the Roaring Twenties' components was the roar of laughter. Corey Ford, late of the *Jester* and one of the decade's rising stars, called it the Time of Laughter.

Frank Sullivan remembered, "We lived in a fool's paradise, or on the edge of a volcano; take your choice." He referred to the heady atmosphere of booming prosperity, the cynicism wrought by the uneasy aftermath of the "War To End All Wars," the speakeasy subculture, women's emancipation, epidemic lawlessness, and rapidly shifting moral traditions. Ford evoked the lighter side with a vision of a virtual Heaven of Humor: F.P.A., Marquis, Woolcott, Broun, and Sullivan in the dailies; Lardner, Parker, and others in the monthlies; Benchley and Sherwood in *Life*; W.C. Fields,

DISSATISFIED WIFE—*And to think that today I could have been the wife of a six-day bike racer—if I hadn't listened to your rot about Higher Art!*

Will Rogers, and the Marx Brothers live on Broadway; Chaplin, Keaton, and Lloyd in the movies. In the comic strips, George Herriman (*Krazy Kat*), Cliff Sterrett (*Polly*), Billy DeBeck (*Barney Google*), Rube Goldberg and Harry Hershfield held sway, and a unique band of pixilated lunatics produced inspired, screwball, often surrealistic nonsense in the pages of *Judge* magazine.

Ted Geisel did not immediately join this humorous fraternity. After graduating from Dartmouth in 1925, he applied for a scholarship from Oxford and was rejected. But his father caused the local paper, the Springfield (Mass.) *Republican*, to announce that young Ted was going to England to study. "My old man had misread the letter rejecting me," said Geisel. "So he had to send me to save face."

Although Lincoln College at Oxford was just one more step in Geisel's infatuation with academia (he also studied briefly at the Sorbonne and started amassing doctorates only in 1956, when they were honorary), it was appropriate that his chosen field of study there was language. He soon cooled to the discipline after enduring a lecture given by someone with the Seussian name of Sir Oliver Onions.

"He was speaking on the punctuation in *King Lear*," Geisel recalled. "In two hours he had only gotten to Act I, Scene 1. His theory was that in certain folios various semi-commas should be colons and various colons should be semi-commas. I can't tell you more than that; I wasn't listening. I was drawing in my notebook." Geisel's tutor from Dartmouth days, a relative of Thomas Carlyle, advised the budding cartoonist to follow his own educational muse. "He told me that I would get a better education if I left Oxford and traveled with a bunch of high-school history books. Reading about each as I went, I went

to Florence, Rome, Paris, and Berlin."

Back in America, Ted Geisel returned to *Judge*, which had picked up his cartoons during student days. His first "professional" cartoon was printed on October 22, 1927, and almost immediately Dr. Seuss became a permanent fixture on the staff. He joined Sid Perelman, who was already a regular contributor, and a celebrated band of crazies that included Milt Gross, the Yiddish dialectician and free-wheeling cartoonist; cartoonists Percy Crosby, Gardner Rea, and R.B. Fuller; and editor Norman Anthony, surely one of the greatest editors and talent-hunters of his time (he was to give many others besides Seuss and Perelman their first national exposure; he later edited *Life*; and he founded *Ballyhoo*). *Judge* had its serious and respectable sides too; George Jean Nathan reviewed drama, and Pare Lorentz (another Anthony discovery) reviewed film.

*J*udge was at the time the premier humor magazine in America. Founded in 1881 as a Republican version of *Puck*, which it managed to outlive (*Puck* died in 1918), it had transformed itself from a political-humor magazine to a social-humor weekly. Since the 'teens it had outsold *Life*, the humor-and-cartoon weekly founded in 1881 ("That was the *Life* magazine that was *intentionally* funny," someone once observed), and routinely left the newborn *New Yorker*'s circulation in the dust throughout the 1920s. *Judge* was so central to the mainstream of currents in American humor of its day that Harold Ross had even been an editor and vice-president there the year before he founded the *New Yorker*.

So Dr. Seuss's employment by *Judge* was not inconsequential, and neither was it casual. Anthony liked his stuff, and soon Seuss was providing several cartoons and one article for virtually every issue. In this routine he resembled Perelman,

just as their zaniness seemed of the same source: both men drew cartoons and wrote articles, though by the end of the decade Seuss gravitated more toward the cartoon and Perelman concentrated on text pieces. In the case of both, their forgotten work is certainly worthy of study and enjoyment.*

Seuss's text pieces were nonsensical essays, often in the form of memoirs or historical treatises. Self-deprecation reigned in his first-person pose, as he went beyond the "Doctor" monicker to become Yogi Seuss, Garibaldi Seuss, and, with a flourish, Theophrastus Seuss. The cartoons dealt with inventions, oddball personalities, pseudo-scientific explanations, and, with increasing frequency, marvelous examinations of phrases, cliches and turns-of-phrase. Dr. Seuss yielded no ground to the cerebral wordplay then being perfected by Sid Perelman, when he patiently discussed the Horns of a Dilemma (illustrating the type of animal the Dilemma was, how wide its horns, and just how to disengage oneself therefrom) or Nursing an Old Grudge (tenderly picturing maiden offering milk to a wizened gent in her lap).

The good doctor quickly became a favored star of the nation's leading humor magazine, and he was soon painting color covers as well. Predictably, these usually featured his cockeyed people or bizarre animals too. Seuss chose his thematic preoccupations early and employed them throughout his career in magazine humor and well after: He had a sure non-sense of his place in history.

"Curse you, Mr. Whitmann, once more you are off your Beethoven!"
"And again, my dear Gershwitz, you have flown off the Handel."

Punning on Paul Whiteman and George Gershwin—and resurrecting a college gag—Seuss drew this cartoon for *Judge*'s celebrity number, Oct. 29, 1927.

*S. J. Perelman's early text and cartoon pieces have been collected by this editor in *That Old Gang O' Mine: The Early and Essential S. J. Perelman* (Morrow, 1984).

The siren calls of 1920s humor certainly beckoned in different directions. The Little Man school developed at the time, and is possibly the most characteristic of the era, chronicling the everyday guy's efforts at self-preservation in the face of the Modern World. He was Benchley, Harold Lloyd, Charley Chase, Andy Gump, Rudy Nebb, and the unprepossessing populations of cartoons by Gluyas Williams and H.T. Webster. Another school of humor represented more cynical and less bourgeois types: Ring Lardner, H.L. Mencken (and his discoveries like Jim Tully); Don Marquis; John Held, Jr; Percy Crosby; *Moon Mullins* and *Barney Google*. W.C. Fields was to have two screen personas, each definitively representing these two schools.

But the third school of American humor of the 1920s—the Screwball variety—was a more exclusive club. It was the sort that employed zaniness, irreverence, iconoclasm, universal parody, and, sometimes, a literary approximation of anarchy. In print, the practitioners were (sometimes) Benchley, Lardner, George Ade, Stephen Leacock, and, of course, always Perelman. On the stage it was the Marx Brothers, in comic strips it was *Salesman Sam*, *Smokey Stover*, Goldberg, and Gross. Prominent among the magazine cartoonists was Dr. Seuss.

His drawing style was distinctive. At first the penwork was full of cross-hatching and rococo effects, the visual approximations of his prose style, which lampooned musty and formal Victorian conventions. Eventually he was to streamline the artwork, just as the prose was reduced to rhyme in his books. From the start his people wore dazed, almost crazed, expressions; drawn with bugged eyes and carefully rendered eyelashes, they seemed like dippy mannequins floating through bizarre tableaux. And the animals were always

The exterminator-man forgets himself at the flea-circus.

Above and right: Seuss's association with Flit began with two cartoons wherein he used the insecticide as a prop, of Jan. 14 and Mar. 31, 1928.

unmistakably Seussian creations. One is tempted to believe that only God Almighty could have created a larger zoo of varied beasts, each endowed with individual personality and a full measure of anatomical logic.

Only God might have dreamed up a rhinoceros; and, it is said, a camel is a horse invented by a committee; but Dr. Seuss's bestiary is a crowded menagerie of incredible creatures. He started to populate his ark in the pages of *Judge* in the 1920s, and the Cat in the Hat, Horton the Elephant, the Lorax, the Grinch, and many other favorites, all have their ancestors displayed in these pages.

Judge, in spite of its position among humorous journals of its day, was by no means the most solvent of magazines. A few staffers were paid regularly, and freelancers invariably were obliged to threaten suit to collect payment. Somewhere in between was the time-honored journalistic version of chit known as due-bills. Geisel's $75 a week was usually supplemented by products that advertisers exchanged for display space—nail clippers, soda water, shaving cream, even hotel rooms in Atlantic City. Some freelancers received *only* due-bill remuneration. Bill Holman (later the creator of *Smokey Stover*) recalled living in luxurious rooms

MEDIAEVAL TENANT—*Darn it all, another Dragon. And just after I'd sprayed the whole castle with Flit!*

engine on a transatlantic cruise in 1937; Seuss's book was actually little different from the tone or length of text-and-art pieces he was doing for *Judge* at the time. Like 1986's *You're Only Old Once!* (and, actually, many other Seuss books), *Mulberry Street* was not really a children's book but a pleasant stroll through Seussian whimsey and fancy and nonsense that could appeal to both children and adults.

What began as Geisel's side trip in the children's book field was ultimately of landmark proportions —45 titles, 100 million copies sold,

of a hotel that advertised in *Judge*: "We lived like kings! We couldn't eat, but we lived like kings." And Ted Key, who eventually created *Hazel* for the *Saturday Evening Post* and who served for a time as a *Judge* editor (until he, too, sued the owners) remembered the magazine's business manager raising cash for the proverbial flow by initiating chain letters in *Judge*'s behalf: "Each week he'd take this mountain of dimes downstairs to the bank to exchange for paper money to keep the boys at bay."

Geisel's method of coping with a fame that outpaced fortune took several routes. He eventually drew for other magazines, following Anthony to *Life* and also contributing to *Vanity Fair* and *Liberty*. He illustrated the successful *Boners* book collections of newspapers' typographical errors. He created a comic strip for Hearst, *Hejji*, about a little boy visiting the fantasy land of Baako. Another avenue was opened when the wife of a McCann-Erickson

advertising executive spotted Seuss cartoons in *Judge* that made playful references to Flit, a commercial insecticide manufactured by Standard Oil of New Jersey. Soon he was contracted to draw comic ads for Flit, resulting in a 17-year association that brought his work to the pages of even more magazines, brought him to promotional appearances in garden spots like the Bayonne, N.J., refineries of Standard Oil, and quickened his weird creatures' presences in the American consciousness. Seuss also coined a national catch-phrase, a play upon the Sherlockian "Quick, Watson, the needle!" with which Perelman was making hay— "Quick, Henry, the Flit!"

Ultimately the vagaries of the magazine business and seasonal advertising took Dr. Seuss to the field of children's books. His first, *And To Think That I Saw It On Mulberry Street*, was actually conceived as a nonsense verse while he listened to the rhythm of a ship's

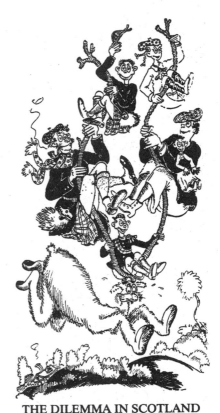

THE DILEMMA IN SCOTLAND
In most countries, when a man sees a Dilemma, he tries to avoid it. But when a Scotchman spies a Dilemma, it is the Dilemma who runs. The Scotch Dilemma is cursed with six-passenger horns, and when a Scotchman catches one, he takes his whole danged family out for a ride.

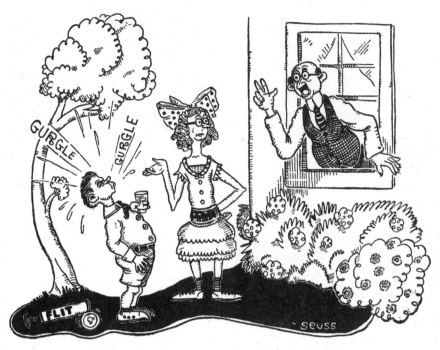

"Don't worry, Papa. Willie just swallowed a bug, and I'm having him gargle with Flit!"

The first Flit ad, June 2, 1928.

translations into 20 languages and Braille. Nevertheless he continued with other varied pursuits. He drew powerful anti-Fascist cartoons for *P.M.;* he also wrote scripts for Frank Capra's Signal Corps Unit in World War II (for which Seuss won the Legion of Merit); he wrote three films that won Oscars (two for the wartime documentaries *Hitler Lives* and *Design for Death*, and one for the strikingly innovative Gerald McBoing-Boing animated cartoons); he designed sets and wrote scenarios in Hollywood (*The 5000 Fingers of Dr. T.*); and he designed toys for many companies. He won numerous awards, including Emmys, a Peabody, a Pulitzer Prize and the Zagreb Critics' Prize. As the force behind Beginner's Books, Seuss's *The Cat in the Hat* represented not just a best-selling classic but a whole new approach to children's literature and reading skills.

Ted Geisel, probably America's best-known doctor not excepting Dr. Spock, is so multi-faceted that many of his interesting, wondrous facets have become obscured through the years. Among the most forgotten, and least deservedly so, is the material in this book. Dr. Seuss's work in the humor magazines is the wellspring for all the marvelous nonsense of his later career; the children, as it were, are fathers to the men...as well as the birds and beasts.

The work in this book represents Dr. Seuss's most inspired pieces produced between 1927 and 1937. Do they seem frivolous and silly? They are supposed to be; Geisel was marching to an absurdist drummer. Are they the work of genius in incubation? They can be regarded by scholars in such a manner, but for readers now—as then, when the leading humor magazines embraced his essays and cartoons—there is pure enjoyment and surprise at this forgotten body of quality material. Are the essays and cartoons inspired humor? They are as fresh and mirth-provoking today as when written and drawn, standing the test of time.

Human nature needs now as much as then to be observed through a prism like Dr. Seuss; the American language should still be dissected; his creatures are ever astounding and hilarious; and the objects of his satire—like corporate America and sex education—are evergreen.

These articles, cartoons, vignettes, and essays are gems of a Seussian treasure that has been buried too long. His wit and imagination in these pages reveal an early but sure grasp of humorous techniques ranging from simple but exquisite punning to literary reductionism. No longer forgotten, they provide a vital chapter in the record of a comic genius of American letters.

The Essays
of Dr. Theophrastus Seuss

General Zachery (alias "Old Zach," alias "Drummer Boy") Corwin

FAMOUS PRESIDENTIAL CAMPAIGNS

The Republican Split of 1867

By
Theo. Seuss, 2nd

Phillip Hornbridge. Loaned through the courtesy of his descendants

For sheer pathos and rock-ribbed brutality there is no story in all American History that equals that of the Infamous Split of 1867. The Civil War was over and General Zachery ("Old Zach") Corwin was trying hard to win the Republican nomination. It was he, as you may remember, who had held Fort Wilmont single-handed against two squadrons of rebel dragoons while Sheridan marched to the sea. In comemoration of this feat of sterling gallantry, Anne Tolbert composed the spirited ballad, "Our Drummer Boy." It ran:

"Oh, Drummer Boy; Oh, grand Old Zach!/Though wounded, you turned not your back./You stayed and stemmed the rebel tide/With nobody else upon your side./So now it is our prime intent/To have you, Drummer Boy, for president!"

These catchy words were set to music and the strains echoed back and forth across the whole continent. Zach went from one city to another on his high-wheel bicycle and spoke in favor of his big campaign point—the high protective tariff.

And then, the night before the convention was to meet, the bombshell was exploded. Andrew ("Sly Andy") Fosdick, a bookkeeper in the Department of Commerce, divulged the news, *that it was none other than Old Zach Corwin himself who owned and controlled the vicious Horsechestnut Trust!*

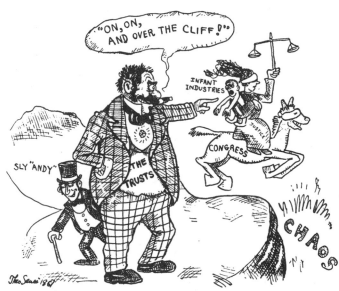

A striking cartoon of the times which greatly aided the Democrats in garnering their victory.

That year had seen a bumper crop of Horsechestnuts and this terrible combine had bought and hoarded up the *entire crop* in a large warehouse in the Bronx, which at that time was the leading horsechestnut center. Readily the scandalized public put two and two together and now saw why Zach Corwin was so eager for the high protective tariff. Incensed, the Republicans nominated Phillip Hornbridge, a shorthand instructor in the Girls' High School, Brooklyn. All the dishonest people in the country still rallied about Corwin, however, and he ran for President as an independent. This split the Republican vote and in the confusion the Democratic nominee, Jas. K. Polk, was elected.

His glorious war record now clouded with shame, Zachery Corwin shut himself up in his horsechestnut warehouse and never came out. Poor Philip Hornbridge lost his job at the High School and died the following Monday—a broken man. And exactly 31 years later war was declared on Spain.

HOW I SPIED ON GENERAL GRANT IN '61

by Dr. Theophrastus Seuss

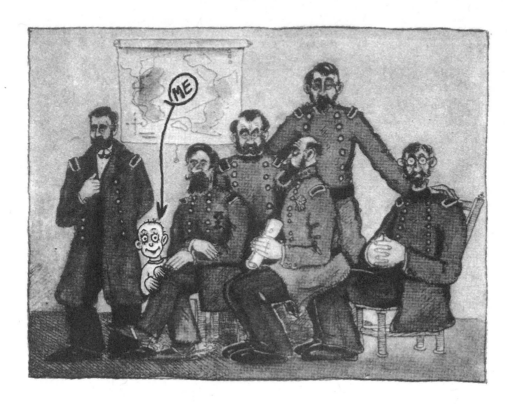

Now that the Civil War is over and harsh feelings are beginning to die down, I feel that my story may safely be told. Prior to the terrible conflict between the Blue and the Gray, our family was very rich and very cultured and we lived together on our huge cotton plantation in Louisiana. My father's name was also Dr. Theophrastus Seuss, but at that time he was never confused with me, as I was only three years old and had not as yet taken my degree at the university.

My three short years of infancy were heavenly. I have a fond recollection of sitting in the *patio* and watching my father through binoculars as he rode through the sunny orchards on a large white palfrey, superintending the gathering in of the sheaves. But then came the dark cloud of warfare which rumbled o'er the nation, blighting lives with its cruel steel cleats! It happened on the morning of my third birthday. Unconscious of impending tragedy, I rose early and eagerly looked into the stocking I had hung up for presents the night before. Imagine my surprise when I found the stocking was gone! In its place was a letter, addressed to me in the hasty handwriting of my father.

"Dear Sonny," it read. "Yesterday I received a wire from Gen. Grant asking me to be his Staff Adjutant. This is better than I can do in the Southern army, so I have left for Washington on the 4.56, taking your stocking with me as a keepsake. Love, Papa.

"P. S. —Take good care of your mother and grandmother."

For a moment I was nonplused. Then I threw back my little shoulders and accepted upon them the burdens of Manhood. That very afternoon I lied about my age to a recruiting officer and was made a member of the Confederate Secret Service. It was another grim case of Son Against Father, but duty called me and I went!

I was immediately detailed to go behind the enemy's lines and steal some plans that General Grant was said to be carrying concealed on his person. If I got hold of these, Robert

E. Lee told me, the war would be ours in a fortnight. Inasmuch as the Confederate government was broke, I had to work my way north on a cattleboat, but being young, I somehow managed to survive all the hardships.

Arriving in Washington, I learned that Grant and his staff were on their way to Bachrach's to be photographed for the next issue of Vanity Fair. I got to Bachrach's first and hid myself behind a chair. And would you believe it, when the staff marched in, who should sit himself down on that very same chair but my own dear father, Dr. Seuss! Little did he suspect my presence, though my deep feelings and powerful emotions threatened to betray me more than once. It was the staff's first photo together; they were awkward and shy and it took Mr. Bachrach some forty minutes to get a good picture. And while he was getting the picture, I snitched the plans out of General Grant's pocket! Ten minutes later I had stolen my father's own horse and, froth-covered and dusty, was racing along to deliver them to Lee in the South.

Alack! Little did I realize that I, too, had been caught in the photograph at Bachrach's! When morning came and I was only half a mile from the Confederate lines, I passed a Union sentry who was sitting on the roadside reading an early morning edition of that fatal magazine. He scrutinized my features carefully as I galloped past and then jumped to the pursuit. In a thrice he had slipped handcuffs onto my protesting wrists! THE JIG WAS UP!

I spent the rest of the Civil War in a New Jersey prison. As I was only three years old they didn't dare hang me for fear the tabloids get hold of the story, so they strung up my father instead. When they offered to bind his eyes with a handkerchief he waved them away with a grandiose gesture. "Not with that rag!" he protested. "Blindfold me rather with this!" And he handed his executioners the stocking he had taken from my bedside. A great sentimentalist, my father! And had the terrible war never been, I am sure we would have grown up together as the very best of pals and companions.

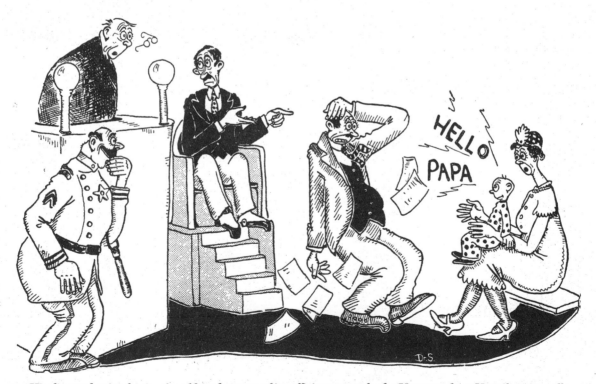

His divorce having been refused him because of insufficient grounds, the Unscrupulous Ventriloquist pulls a fast one on his wife and her attorney.

THE ORIGIN OF CONTRACT BRIDGE

An Historical Treatise by the Eminent Philologist, Dr. Seuss

It was all more or less an accident, so I take very little credit for the discovery myself. My brother's son, Anatole, a stripling of five, was down in the cellar of our London home not long ago making pop corn for my birthday party, when all at once the cellar caved in. Anatole, poor tot, woke up on a nasty pile of rubbish in a vast dark cavern some thirty feet below the level of the cellar.

"I say!" ejaculated Anatole, after examining the walls of the musty place by the glow of his cigar lighter. "This is an old Druid Temple!" It seems that our house had been built upon a foundation of ancient ruins without anyone being the wiser! And Anatole was the first to break entry since the last Druid was chased out of England in the memorable Battle of Hastings, 1066.

For three days, the lad's curiosity led him hither and thither in the endless network of subterranean chambers. One passageway led to

HOW THE GAME WAS FIRST PLAYED
Aethelstan has just bid three diamonds. Beowulf is just about to take him out in his strongest suit, or Smekyd-Skirmyt, as it was then called.

*My nephew, Mr. Dahmen,
who made the discovery.
(Note the old-fashioned engine and
coal car, now obsolete so far as the best
railroads are concerned.)*

another. Anatole forgot all about my birthday party, so absorbed was he in the rare relics he was discovering. He wandered over *thirty-seven miles* underground before he finally emerged through a muskrat hole on the banks of the Thames.

Like all Oxford men, Anatole is a great connoisseur of antiques. Among the things he picked up were forty or fifty saw-tooth knives with which the Druids sacrificed dingo dogs to their gods in 25 B.C., an ossified doughnut from under the altar, and a Roman coin which without the shadow of a doubt fell from the pocket of Julius Ceasar when he visited the Druids in the autumn of 52. But most important by far was a musty parchment man-

uscript written in Anglo-Saxon shorthand. With my aid Anatole translated this startling document. Imagine our thrill when we read the vivid and breathtaking description of the *first game of bridge!*

For the benefit of those who cannot read Anglo-Saxon in the shorthand, I have illustrated the birth of the game. It seems that one balmy May afternoon in 12 A.D. three fun-loving Druids, Aethelstan, Beowulf and Flloyd-Jones found time heavy on their hands and invented Bridge just as you see them doing in the picture.

Once established, bridge took the country by storm. Poker—then an unsatisfying game played with a number of antlers and a thimble—

was dropped in its favor. And the vast kennels of wild rabbits with which the rich men played at pinochle were thrown open and the rabbits turned free.

Every twelvemonth a national bridge joust was held in the big elderberry forest at Camelot, where five thousand picked players vied for the cup which at that time was a hatchet. What a spectacle indeed as they pranced, white-shirted, from thicket to thicket, now "skyrling" (*to deal*), now "grytzend" (*to trump*)!

To be sure, in the course of the intervening centuries the game has undergone a few minor changes. Today, for instance, there are four players instead of three, and they play with cards instead of croquet mallets. But the underlying principle is the same, and principle, afterall, is the only thing in the world that counts.

"By Gad, ain't it the truth? Those rascals will eat most anything!"

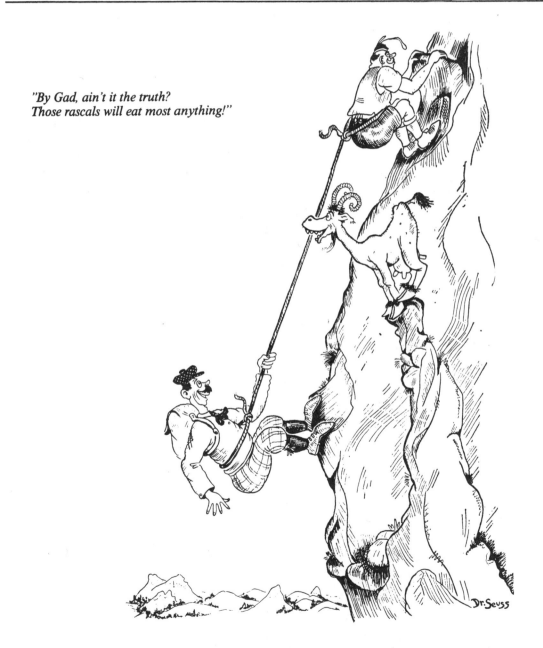

THE CLOCK STRIKES 13!

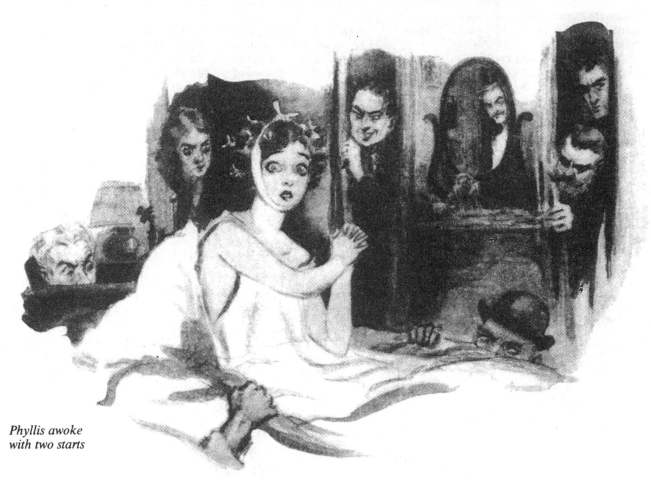

*Phyllis awoke
with two starts*

A NEW SERIAL OF LOVE AND CRIME

By Henry McSeuss Webster

SYNOPSIS—Phyllis Whyllis, no bigger than a pint of cider and three times a graduate of Smith College, is in love with some of the ushers at Roxy's, and as a punishment her family has found her a job out of town. As private secretary to old, irascible Colonel Gimbel, she is finding life very trying. He is slightly inclined to epilepsy and lives in an old, rickety mansion surrounded by poplars that groan like lost souls in the wind. He has ratty white whiskers and for a man eighty-eight and a half, going on eighty-nine, his eyes are bright with a hard gleam of insane cruelty. The best part of each day he spends writing codicils to his will, disinheriting his grandparents, whom he believes to be alive in the form of two gray chipmunks and whom he keeps in a cage in the cellar. And all through the long hours of the night he hobbles, muttering to himself, through the creaking, musty corridors in search of a spirit called Lucy, the circumstances of whose death Phyllis has yet to learn.

Last night at dinner Niobe, the wrinkled, old red-eyed maid, suddenly fell to frothing at the mouth while serving the turnips and died across the table. Just a mite embarrassed at this unexpected turn of things, Phyllis has retired early, only to be awakened just before dawn to find a goodly number of ghosts and other intruders leering in at her through the secret panels of her attic bedroom. As you may well imagine, this has made gooseflesh appear all over her otherwise perfectly proportioned little body.

Part Eleven

Phyllis lay rooted to her Ostermoor, breathing small. Then, gradually regaining her courage, she breathed larger and larger.

"Well, boys," she started to say...and then stopped. Looking over the footboard of her military cot she had spied a bit of lint cluttering up the rug in front of her bureau. "You must excuse me, gentlemen," she interrupted herself, "while I tidy up the chamber." Tidiness was only one of the many traits that made Phyllis so desirable.

Slipping into a soft *beige* negligee Phyllis stepped seductively out of bed. As she glided across the room, the moon slid out from under a cloud and flooded her milk-white shoulders with a most bewitching light. (By this time, of course, the goose-flesh was all gone and Phyllis was the most adorable thing you ever saw.) She stooped over to pick up the lint.

"My word, but you *are* chic!" came from the piece of lint which really wasn't a piece of lint at all. What Phyllis had mistaken for lint was the ratty white beard of old irascible Colonel Gimbel himself in person!

A marrow-curdling laughter rang out in her ear. Phyllis Whyllis wheeled about just in time to see the other intruders disappear down a trap door under the bed. It was all a HOAX! Phyllis, her marrow helplessly curdled, found herself alone in the room with the mad octogenarian! He reached out with his writhing vile arms to grasp her.

"Jumping Judas!" screamed the poor girl. "Is there NO ONE to save me?" And as her frenzied shrieks penetrated through the hollow corridors of the ghastly old mansion, they were joined by a new and more ominous sound. The clock in the library was striking thirteen! Phyllis phainted.

By a fortunate coincidence, Roxy's Theatre will soon be shut down for repairs, thus leaving her lovers, the ushers, free to rush to her rescue! But read it yourself... in NEXT WEEK'S ISSUE.

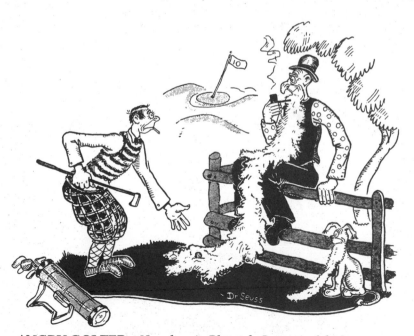

ANGRY GOLFER—*Now, how in Blazes do I get out of this?*
THE WHISKERED ONE—*Wal, Bud, I've been awatchin' 'em drive in and out of this here beard nigh onto fifteen years, and I'm about convinced the best bet is the niblick.*

HOOEYANA...A REVERIE

By Theophrastus Seuss, 4th. (Class Whimsey)

The ivory-covered halls of Dear Old Hooey mean more to me, perhaps, than to any man alive, insomuch as I am the fourth successive generation of my family to nestle in her bosom. Daddy, Grand-daddy and Great-grand-daddy, too, were all right here before me, In fact, at one time they were all right here together and constituted the greatest flying wedge our football team had ever known. (For years none of them could pass their Greek.)

I had just turned thirty-two when I entered college. I had begged and begged to be sent sooner, but as Daddy had not yet mastered his Greek, Grand-daddy could not afford to send us both. At last in 1918 Papa graduated with honors, and after he had got his start in business I moved into the family room in the old romantic Nathaniel Moses Morgan Memorial Dormitory, Jr. Still fragrant with souvenirs of the Seusses who had gone before, the quarters made a profound impression on my sentimental person. I was young for my age...a relatively unblown bud.

Unlike my forbears, I was not athletically inclined, preferring rather to spend my time in making whimseys. It is with signal pride, therefore, that I accept the honor my schoolmates have conferred on me in the privilege of writing this allegorical history of "our Hooey days together."

In Figure A, I have represented myself as a typical Freshman...a delicate thirstling bending o'er the "Pool of Knowledge." Timidly I moisten my tender trembling lips, and as the stimulating liquid trickles down, I am awakened to the

Figure B

Secrets of Life, represented from left to right by six little animals and a couple of sparrows, meaning respectively Chemistry, Penmanship, Comparative Obstetrics, Phlebotomy, Chastity , Stick-to-it-iveness, General Motors, and the Musical Clubs.

In Figure B, I have striven to capture the elusive spirit of riotous unrest, typifying the Sophomore and Junior year. I picture myself as prancing giddily about on the unsteady back of a Dilemma, futilely clutching at the unsubstantial soap-bubbles of "Error." It was during this trying period that our unfortunate classmate Carlos Wormser lost his head and ended up married

Figure A

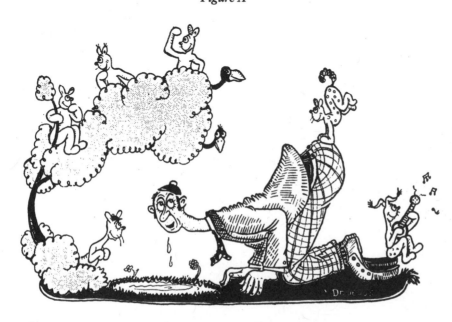

to that Polish girl who worked in the laundry down on Byers Street. The geranium in my teeth signifies "Hope."

Figure C shows me as the serene and collected product of a thorough education. The hectic days of intellectual puberty are over, and I am at last qualified to fill whatever niche awaits me in the outside world, be it Bonds or Life Insurance, and I think I have done wisely in choosing the latter. On the right, his tail embellished with the coveted watchfob of Phi Beta Kappa, is Sennacherib, the constant nymph of all good sons of Hooey. He sits in thought upon the North Pole and signifies "Cool Reason."

Classmates! Four years ago we crept up to the Alma Mater's shrine. Her latch string was out to us, and like unformed potter's clay, we pulled it. She took us under her fluffy warm wing. With her flint and steel she coaxed sparks in our brains and leaped on many timbers. Let us salute her, oh classmates! for she has been just too "white" for words.

Figure C

Dispossessed by their landlord, the juggler's family starts out in quest of a new apartment.

THE CUTTING OF THE WEDDING CNOUTH
or, Divorce Among the Druids

There was one particular period in the era of the Druids when these good fellows worshipped Sulky Dogs. At other periods, of course, they were very versatile. At first it was pine-needles; then it was an old bit of whale bone out of a corset that had washed ashore after a French excursion boat had gone on the rocks; after this they worshipped echoes; while at still another time it was buttered popcorn with lots of salt. But at this particular period the Druids would bow down to nothing but Sulky Dogs.

Every temple and shrine was a veritable pound. Every private home had at least one household dog perching gloomily upon the mantelpiece. And this is why (according to Calkins and Oliphant's *Druidiana)* there were so very many divorces at this stage of their civilization. With a sulky dog grumbling and grousing around the house from morning till night, what could one expect?

Soon the divorce epidemic grew to such serious proportions that the high priest, Sceolothan, realized that only drastic action could save his flock from impending chaos. So the white-bearded old codger designed and put into operation a form of "Cygcelh" (Divorce Court) which to this day has never been surpassed. The diagram illustrates this, the only practical system of divorce procedure the world has ever known.

Mr. and Mrs. P. Dipthong Fraeng, Druid Suburbanites, have ceased to find mutual satisfaction in the holy state of *Cealfru,* as it was then so aptly put. Fraeng, a traveling man, suspects that his wife has not been especially concerned with fidelity during his absences, a fact which may be true, but more than likely is just a product of his dog-distraught imagination. Having donned the traditional "Jacket of the Broken Heart," he has encased his head in one end of the *Wedding Cnouth* in which they were wed. His wife, having stuck her head into the other orifice of this to-us-unusual hat, has

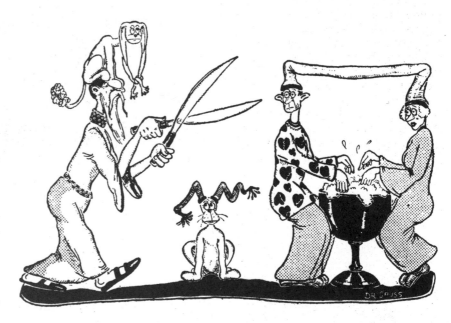

accompanied him to the Bowl of "Sacred Soap and Water," in which they are symbolically "washing their hands of the whole affair." Beside them sulks their household diety, his ears draped in the official denim.

The gentleman with the hedge-clippers is, of course, Sceolothan himself. With his eyes blindfolded by the soft paws of the Chief Dog of the Tabernacle, he has already begun to clip. He will wander about for an hour and a half and clip anything that gets in his way. At the end of this time, should the Marriage *Cnouth* be among those things clipped, the couple will be awarded their divorce.

Fortunately, two weeks after dog-worship was initiated, an epidemic of rabies laid low every canine in the kingdom, and the Druids took up the more sane worship of an anthracite soup ladle. Once freed from the yoke of the Sulky Curs, however, the Druids throve as never before and from that day to this divorce has been on the steady decline.

A GENTLEMAN IN THE CASE

Sea Story.

Like my predecessor, Columbus, I was born in Genoa, and found business very, very rotten indeed. Day after day I slaved away in a shoe factory, lacing up new shoes with old tough strings of cast-off spaghetti. Here was adulteration of merchandise for fair....No wonder I longed for America, with its religious, social and economic honesty! I languished like a bird in a cage.

Then one day in the back yard of the factory my eye fell upon one of those six-foot packing boxes in which the steel wool comes with which we line our shoes. I remembered how once a colored gentleman had smuggled himself into America in a one-foot box, and I realized that here indeed was my cabin for my Great American Voyage.

"How mucha thesa box?" I asked the factory superintendent in Italian.

"Fiva lira," was his rock-bottom price. I closed the bargain. But as this was just twice as much as I intended to pay, I determined to defray the expenses by dividing it into two compartments and taking along a fellow tenant. After selecting the ship on which I was to smuggle myself and my companion, I advertised in the daily papers for the companion, wording the ad somewhat enigmatically, lest the customs officials catch on.

"*Roomer wanted,*" my ad read, "*to occupy second floor of sea-going bachelor apt. Unfurnished. No dogs. Ten-day lease, three lira.*"

My hopes, however did not materialize. Only one applicant showed up, and as this was a woman, my fine Italian sense of decorum forced me to turn her

down flatly. It was *her* reputation I was thinking of.

On the morn of embarkment the extra room was still unrented, so I had to sail with it empty. I snuggled up cosily in my new "home," my brother nailed the cover down, and with the aid of my little sister, he carried the crate aboard ship.

At the gang-plank the captain stopped us, raising one eyebrow in suspicion. But Brother Guilliano rose magnificently to the occasion.

"For the deck sports," he explained, prompted by a lightning stroke of genius. "A box of sand for the marksmen to shoot against." (Leave it to Guilly to know that the Olympic rifle team was aboard!) So the captain let us pass. They plunked me down upon the top deck and wished me all sorts of heartfelt godspeed. But not until they had tacked up targets all over the box to make their story hold.

A most eventful voyage ensued. That is, at night. The days frankly,

were boresome. I lay there, curled up for ten days, listening to the marksmen's bullets whistle through the top compartment. Fortunately for me, my brother had nailed most of the targets high, and I was struck only fifteen or sixteen times during the trip, most of the wounds being of a superficial nature. Seasickness I suffered but seldom, and my exercise consisted mainly of executing simple clog and softshoe steps upon the ceiling when the rattle of the musketry was sufficient to cover up the noise. My mind I kept alert by holding spelling bees with my six imaginary roommates, Ludovico, Donatello, Benvenuto, Bratiano, Ben and Caspar. But all this, diverting as it was, was dull in comparison with those long intriguing nights of romance.

I fell in love! I never saw her, but from her voice I gather that she was a stunner. Fickle? Perhaps. But her fickleness was only another indication of her overwhelming *joie de vivre*. Every night she would come there with a different man and make love to him as they sat snuggled against my crate in the invisible moonlight. Her fickleness only tended to torture my desires all the more and to cause my love to soar and transcend itself a thousandfold. And all the while she would kiss the other fellow. Many times I would sob aloud and call her softly by name, but Gertrude (her name) would think it was her escort calling, and he would reap the sweet reward.

And so on, night after night, until I knew that no one e'er had loved like I. It was with doubled thrill that I heard the anchor drop at last in N.Y. harbor. In another hour I would be free...free to meet this

maiden face to face! I knew for sure that once she saw me, she would love me, too. Oh, happy fellow, I, when I felt myself hoisted up. My crate was carried to the customs office.

"What's in this box?" asked an officious voice, chilling my marrow with momentary fear.

"Only sand," said another voice, "No need to open it at all." My spirit soared and lilted. And then, as if so arranged by fate, I heard sweet Gertrude's voice. The lovely girl was standing by my very side! I could not restrain myself.

"Gertie!" I hummed out softly.

"Who calls?" her startled voice came back.

"'Tis I...the guy in the box," I answered. "Put your address on a slip of paper and shove it through the crack."

But before she could do so, the customs official had caught on. In the morning I was on my way back to Italy.

Once more I am working in the Genoese factory...more unhappy than ever. For I know that somewhere in that vast America to the west waits Gertrude, my unseen sweet. The United States Customs Dept. has added another brace of broken hearts to its inhuman record of shame.

Curator of Dime Museum—*And here, ladies and gentlemen, we have the most minute piece of microscope engraving in the world...the Lord's Prayer on the Head of a Pin!*
Atheist (to son)—*Don't read a word of it, Robert! It's all propaganda.*

SEX AND THE SEA GOD

A Frothy Novelette

It was dawn when Babe Ruth tip-toed his way into the Russian ward of the Bide-a-Wee Maternity Hospital. It was his custom to come there every dawn to autograph baseball bats for the newborn boys, so that they would grow up to be good citizens. By the time he had reached the last cot on this particular morning, he had autographed five dozen Louisville Sluggers, a gross of fielders' mitts, two pop bottles and a catcher's mask. The infant in the last bed he could not see, but from beneath the sheets there came a steady, mournful sobbing.

"Don't cry, my little man," said the great-hearted athlete, "I'll autograph your — — bat."

"Bat, hell!" boomed a voice like the bellowing sea, and much to the Babe's nonplussion, an unexpected head popped forth! It was not the dome of a rosy little infant; it was the white-whiskered conk of a grizzled and sunbronzed old codger, and instead of a dainty lace bonnet, he wore a battered and mossy brass crown. On the end of his *schnabel* was a barnacle.

At this point an interne stepped up. "Mr. Ruth," he said, "shake hands with Mr. Neptune...the sea god, you know. He was brought here last night after a very unfortunate accident in the Hudson, where he was rammed by the ferry-boat *Weehawken*."

"And please," begged Neptune, "keep it a secret. The one thing that I dread in the world is publicity."

But the secret had already leaked out. The door of the ward was suddenly burst open and in rushed a wolf pack of howling reporters. Leading them by several lengths was Grover Whalen. "Mr. Nep-

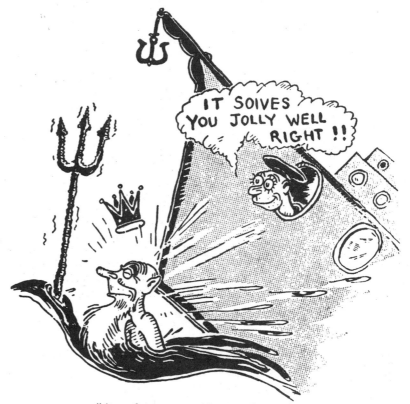

"An unfortunate accident on the Hudson."

tune!" he panted, "in the name of the city, I present you with the keys to the Aquarium." But Neptune was gone. Nude as he was, the terrified man had taken to the fire-escape.

Through the tangled maze of downtown streets the frenzied sea god raced, a hundred yelling reporters sprinting in the wake of his floating beard. It was on the top of the Woolworth Tower that the poor man was finally cornered.

"Come on, you old sea fox," coaxed a representative of a tabloid. "The public wants a good red-hot confession. Tell us...what was the

greatest temptation of your inner-most private life?" Neptune blushed indignantly.

"No stalling, you old reprobate, you," he was warned. "Come clean and make it dirty."

Seeing no possible way out of it, Neptune gave in. "Well," he growled, "it all took place a few years back...right in the plumb middle of the Mediterranean Sea. I was on my way home, having just completed a three months' inspection tour of the Associated Homes for Aged and Pensioned Mermaids. And let me tell you I was pretty well fed up, for all this time I had not

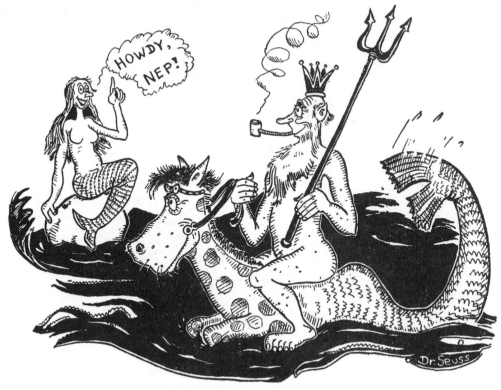

"She cooed to me."

once laid eyes on a mermaid under eighty. It was a miserable, rainy day, and hour after hour I trotted sullenly along on sea-horseback through the drizzle and mist. Beauty and warmth, that's what my soul craved . . . when suddenly it got it. Unexpectedly, the sun burst forth through the clouds, and as the fog dispelled I saw, not a clam shell's throw ahead . . . a lone and lovely mermaid!

"Seductively she lounged on the verandah of her cozy one-rock apartment. Her lips were red and eager like a snapping turtle's. She had been eating oysters, and her mouth was still chock full of pearls, which sparkled mischievously when she smiled. A young wild thing with sea-green hair she was, just the kind of a mermaid the boys like to take on a sleigh ride. And there we were alone . . . alone in the middle of the sea!" (The sea god's reticence was gone; he had lost himself in the memories.)

" 'Nep!' she cooed to me, using the familiar diminutive, 'Nep, you old big haddock and shad-roe man from the west, come on over. Momma and Poppa have gone to the mountains for the summer.'

"My first inclination, of course, was to rush right over, but as I glanced around for a tree to tie my horse to, a torturing indecision came over me. I remembered that I had been born and brought up a good Methodist, and realized that to go over would be highly opposed to their method. I sat writhing while my desires wrestled with my inhibitions. I sat pulling mad fistfulls of whiskers out of my beard. And that moment, gentlemen," said Neptune, "was the moment of my most acute temptation. Now let me go."

"But wait, man!" cried the expectant reporters. "What happened then?"

"Never mind!" retorted the sea god, as ruddy as a lobster.

"Come, come, Daddy Neptune," they teased.

"My dear young men," said the god after a moment's thought, "Have you ever seen the sea?"

"Of course," they flung back. "Often."

"Well then," said Father Neptune, unwilling to commit himself in so many words, "you certainly must have seen all the sea urchins." And, terrified at having laid his soul so bare, he hopped the express elevator to the ground floor and galloped away toward the harbor. He was last seen off Sandy Hook, still blushing furiously as he splashed his way to sea.

DOING ENGLAND ON NINETY CENTS

An Ingenious Bit of Subtlety which Enabled Two College Boys to "Get In With" the Best Families in London

One evening last spring two well-known Columbia athletes were seated about their well-loved training table in the Automat.

"Tod," said Gootch, pensively spinning a doughnut around and around on his spindle-like tongue, "for years we have played together on every sporting team in the college. From the strenuous 'give and take' of our vibrant life I believe we have conned the one real secret of success...and that is *teamwork!*"

"Gootch," mused Tod. "Why cannot this same unselfish teamwork enable us to spend the coming summer in England?" Stacking their combined pennies in one column on the table before them, Gootch did some rapid mental arithmetic.

"Nine inches of pennies, at ten pennies to the inch," he said, "make ninety cents exactly. The trip is more than possible." It was decided that they should travel incognito—as mother and daughter. Gootch was given the mother's role because of his moustache, which made him look so much older.

"Well," said Tod a few nights later, "here we are in London. Our next move is to get in with the best English families." It was damp and cold—an ideal night for their well-laid plan. How cold it was! Many poor people were caught out that night with their marrow unprotected and were severely chilled to it. Big Ben had just tolled the cheerless hour of twelve when the Hon. Cecil J. Mobrey-Weymouth, a policeman, came upon two pitiful, shivering figures huddled in the murky glow of a street lamp. They were mother and child of four, and their sobs brought a sadness into the tender bobby's heart.

"Please, sir," whimpered Tod, "Mumsey and me...we is lost."

"Please, sir," whimpered Tod, "Mumsey and me...we is lost." Tears filled the constable's eyes.

"And who are you?" he asked, also beginning to sob.

"Two derelict soul-ships upon the foam-tossed sea called life,"answered "Mother" Gootch. "We are Flotsam and Jetsam, respectively."

"Come with me, poor chucks," said the kindly Politzei, and he led them to his town home. Using this as their headquarters, Tod and Gootch saw a great deal of England in the three long months that followed. The policeman had a half-brother who was at that time a member of the House of Lords, and it was through him that the boys, or rather "girls," made many social contacts, being constantly entertained at steeplechases, diplomatic dinners and many a good May Breakfast.

It was their unusual athletic prowess that made the nobles seek their friendship. How they marveled at Tod! Here was "she," an infant girl of four whose favorite sport was boxing! At one especially arranged benefit performance she knocked out the Oxford heavyweight champ in one short round. Nor could the lords and ladies believe

31

their eyes when Gootch, supposedly sixty-three (and a mother to boot) jumped from her foaming horse in the course of a chase and raced ahead to catch the fox by hand! No wonder they were feted!

Had it not been for an unfortunate break made by Tod, their Cinderella Days would never have been ended. It happened at a surprise party given by the Duchess of Camershorn in honor of the little "tyke's" fifth birthday. Seated in the center of an admiring throng of lords and ladies, little Tod was wistfully cramming himself with goodies. So fast was he eating them that in his excitement he bit Lady Featherstone on the hand, thinking it was a ladyfinger. He was embarrassed to death, but the Duchess, who had hitherto been silent, passed it off as a good joke and playfully slapped Tod on the nose, breaking it in two places. Tod got very mad and came back at her with a feint and a right cross to the chin, and she went down for the count of nine, causing a hearty laugh among the crowd.

"What is it you like the best about England, my little lady?" suddenly asked the Duchess. (At that moment Tod was happily munching a delicious buttered Crumpet.)

"I like the way you English make your Strumpets! he bellowed out.

Unfortunately, he was overheard, and from that moment on, the doors of British Society were a closed book.

"G'wan, sit back in the water, big boy! That's a deuce of a place to get sunburned!"

THE WAITING ROOM AT DANG·DANG

Where the D.T. Animals Stay When They're Not Out On Jobs.

Bringgggggggg! The telephone bell. Mr. Fronk, Gen'l M'g'r and Supt. of the Beasts of Delirium Tremens, Inc., picked up the receiver.

"Hallo...whazzat?...Right away, sir. I'll send 'em right down." Fronk put down the reciever and called to Alk, the Delivery Boy. "Alk, put pink neckties on a carload of purple hippos and send 'em down to 20 Christopher Street...rush! Big gin party in progress."

Again the telephone. This time a far-away voice greeted Mr. Fronk's ears. "San Francisco speaking. This Fronk? I'd like to get hold of a few rainbow elephants and a brace of flaming flamingoes...No, no hurry...any time this evening ...party in question is drinking absinthe."

Mr. Fronk entered this on the order blank, and as he did so, the phone rang once more. "Looks like a busy evening, Sturdevant," he remarked to a polar bear who sat nearby, playing a bass viol.

"She sure do, Massa Fronk," was the bear's laconic response, and with this he launched into the irresistible third movement of Beethoven's Fifth.

"What's yours?" asked Fronk into the telephone.

"This is the manager of the Cambridge branch," came the voice over the wire. "And I want a little help. A gang of Harvard law students is tossing off fuel oil highballs over at 4 Arlington Street. This is a new one on me. What'll you send 'em?"

For all his experience, old Fronkie was stumped. "Wait a minute," he stalled, and holding his hand over the mouthpiece, he put it up to the "boys." "A volunteer wan-

Mr. Fronk, Gen'l Mgr. of the Beasts of Delirium Tremens, Inc., has just put pink neckties on a carload of purple hippos and shipped them out to a big gin party in Brooklyn. He is seen taking the order for a magenta puppy with parthogenetic proclivities to be sent to the scene of an absinthe orgy in Cambridge, Mass.

ted...to go to Cambridge, Mass.", he said. "Complaint is fuel oil."

A big beige elephant held up his hand. "I'll take the job," he offered. "Under the condition, of course, that if I like it, I'll get all the fuel oil jobs in the future."

"It's a go," said Fronk. "Two flights up, and ask for Mr. Campbell." And the elephant trotted off, lingering only long enough to light up a fresh panatella.

At six a.m. Mr. Fronk sent out the last animal in the place, a handsome magenta puppy with parthogenetic proclivities.

"Ho hum," said the sleepy Mr. Fronk. "Another night's work

done." But just as he was about to close up shop, the irritating tinkle of the phone bell called him back.

"Not a chance in the world," snapped the weary Mr. Fronk. "There ain't a beast left in the place." And he tried to ring off.

"But...lissen here!" argued the voice. "You've simply got to fill this order. It's for two bone-dry Congressmen getting lickered up down in Washington."

"Oh, well," sighed the conscientious Mr. Fronk. "After all, one can't disappoint one's best customers." And saying so, he put on a pea-green kangaroo suit and went out on the job himself.

THE HARASSING OF HABBAKUK

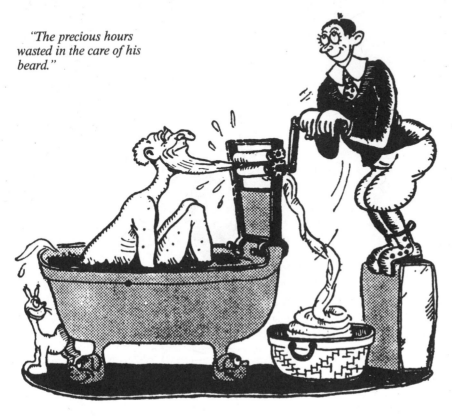

"The precious hours wasted in the care of his beard."

When, in the year 1876, my grandfather Habbakuk received his diploma from the Albatross School of Fancy Dancing and Inventing, the valedictorian praised him in the following terms:

"Out of a class of 320, exactly 319 of us have chosen Fancy Dancing as a career. Only one of us has selected that most ambitious and hazardous of all possible vocations—that of a Free Lance Inventor! I refer, of course, to classmate Habbakuk. Habbakuk goes forth to the fray unaccompanied, but rest assured, brother graduates, that it will not be long ere all sons of Albatross will point to his record with pride!"

By the end of July, true to this prophecy, Habbakuk's name was on the lip of every suckling and babe in the country. Great was the happiness he brought to the tots with the invention of his *character doll.* Habbakuk's doll could actually sniff up snuff through its little porcelain nostrils! This was the five-dollar model for boys. The ten-dollar model for girls was even more delicate, and if it got cinders in its eyes that it could not blink out, it would daintily remove them in the cutest way with a doll-sized eye cup and saucer.

Grandaddy had proven his mettle. The eyes of the world were upon him, waiting the development of his next great invention, the "Little Jack Horner Ballot Box Stuffers." That autumn Rutherford B. Hayes, the great Republican, was running for the presidency against that sterling Democrat, Nelvin I. Tippicanoe, I believe, but am not quite sure. Rather fancying the euphonious sound of the Democrat's name, Habbakuk determined to try out his invention by stuffing ballot boxes in his favor. So certain was grandfather of his candidate's victory, that he wagered heavily on the outcome. "If Hayes wins out and the Democrats lose," he vowed, "I shall never henceforth shave a whisker from my chin."

The machine worked like a gem! By noon of Election Day, grandfather had personally stuffed every ballot box, letter box and slot machine in Manhattan. That afternoon, to make the cause more certain by stuffing the boxes in Brooklyn, Habbakuk went down to the river and boarded the clipper ship *Flittermaus.* In 1876, as a glance at your atlas will show you, there was no Brooklyn Bridge at all. More surprising even, is the fact that in those days the river was *twenty miles wide,* the crossing of which entailed a perilous voyage, through swirling eddies and over hidden reefs that lurked, by clipper ship.

The boat scarcely left the dock when a sudden raging tempest shook the clipper ship from stem to stern. Grandfather was in the main saloon, and had just sat down to a chummy game of sixty-handed bridge, with fifty-nine beautiful ladies belonging to a high-class

burlesque show. (Lest this put my grandfather before you in a false light, let me state that in that wholesome decade, choruses were recruited only from the very best of families. In fact, women's colleges were not all they should have been, so very often a father would set his daughters up to four years in the burlesque instead.)

The game broke up in a panic! From the seamen's shouts above, grandfather realized that the very worst had happened. The storm had swept the clipper ship upon a reef . . . the *Flittermaus* was sinking!

Deathly pale, the sixty terror stricken mortals raced up on deck. Already a valiant sailor had swum ashore through the vicious maelstrom with a line, and the Breeches Bouy was ready for their use. But the chorus ladies refused to be saved.

"Captain," protested their spokeswoman, "if you think we are going to wear *breeches,* you are sadly mistaken! We are shocked you should even suggest such a thing."

"*Breeches,* indeed!" echoed the others. "True ladies all, we prefer to go down with the ship!"

Grandfather heard this, and the inventor within him awoke. A gallant man, he could not allow the ladies to subject themselves to any such breeches of etiquette. His eyes blazed with his first truly great inspiration! Away to his cabin he raced. He tore open his inventing kit, and his nimble fingers busied themselves with slide rules and gimlets, with adzes and awls. Habbakuk designed and invented as never before. And ten minutes later he rushed back on deck . . . flushed with the thrill of achievement. The clever fellow had constructed a breeches buoy in which the most conventional of ladies could be rescued with decorum . . . *a breeches buoy in the form of a skirt!*

Grandaddy was the last to be rescued. But before he was saved, with

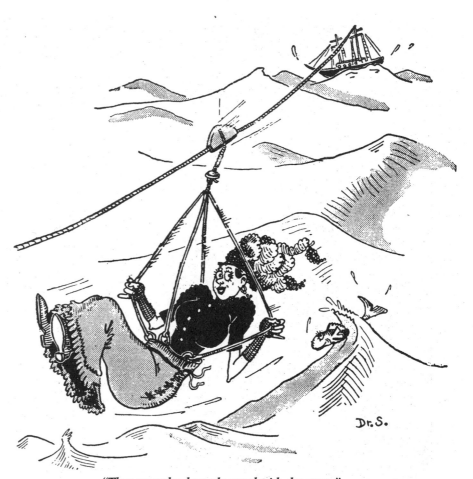

"Thus were the damsels saved with decorum."

one grand flourish he threw his "Little Jack Horner Ballot Box Stuffer" into the sea. Such an invention no longer merited his consideration. The remainder of his life he would devote to the perfection of the Female Breeches Buoy.

Alas, with the morning came the papers announcing the election of Rutherford Hayes. It was with a shudder that Habbakuk recollected his very foolish wager! Reluctantly, but true to his word, he threw away his razor. Weeks passed; his beard grew and with it grew the tragedy of

his life. Before long his whiskers began to interfere with his inventing. They swished across his blueprints and blotted his inky drawings. When he sewed on the skirt, he was forever sewing his beard into the fabric. They got covered with grease, and hours every day were wasted in their laundering. At the end of the year he acknowledged defeat and gave up his cherished career; the breeches buoy was never completed. His ambitions crushed, Habbakuk ended his days in a circus.

THE FACTS OF LIFE
Or, How Should I Tell My Child?

Foreword to Bashful Parents

Somehow, by hook or by crook, your child *must* be told. "But how?" you ask blushingly ...and you shove the matter off day after day, year after year...And the first thing you know your baby has blundered ignorantly through adolescence into willy-nilly adulthood and is awkwardly facing the very same problem of how to tell his own children something he never has learned himself.

And thus it happens that practically no one at all knows anything about the Facts of Life. The author knows of one case of a family in which three entire generations were abysmally ignorant of where they came from, how and why.

Then, finally, in the fourth generation there arose a prodigy. In a hit or miss fashion he pieced the whole story together from fragments of a chance conversation he had overheard between the maid and the man who came to fix the electric flatiron.

With the fortitude of a missionary, this brave tot went straight to his grandfather and let him in on everything. But, alas, by this time the old man's memory was too far gone.

"Run away," he said curtly, "and let me read my paper."

Disillusioned by his granddad's apathy, the child did run away, and rapidly deteriorated into a chronic cenobite.

It was to forestall such a tragedy as this in his own family that the author came to prepare this little volume. There was his nephew, little Quackenbush. Little Quackenbush was growing like a weed threatening daily to burst into the full bloom of long trousers and all that goes with them. And yet, his embarrassed parents had told him nothing. To the author it seemed a horrible thing.

They (the parents) had launched him on the treacherous seas (of life); they had furnished him with an excellent boat (his body); they had given him oars (his mind); but now they had refused to equip him with oarlocks (sane sex instruction)!

It was to furnish these oarlocks that the author took little Quackenbush on numerous little Nature Walks into the Bronx.

Sex had to be faced, for sex is ubiquitous. Neither the author's little Quackenbush or your little Quackenbush can ever hope to dodge it. They will find it in cities; they will meet it in hamlets. Nor can they escape it by hiding in precincts.

CHAPTER I
The Stork, Scientifically Evaluated

For a long time that first evening little Quackenbush and I walked along in silence. Hand in hand we strolled up into the Bronx. He was scarcely more than a child, it seemed, with the bright blue eyes of a cherub. His boyish pelt was soft and peachlike, and his voice was a dainty soprano.

As I looked down on him in the mellow glow of the street lamp on the corner of 145th Street I could not help but think of him as an unsprouted tulip bulb. And I realized more than ever that the task before me must be accomplished with rapidity. Any day now this fleeting phase of lambent boyhood might be swept away. For adolescence comes on like thunder out of China 'crost the bay.

It was difficult—almost a bit embarrassing—to get started tonight, this first of all Walk Nights. Before I could launch into the *real* facts of life, I realized I must first tear down that bugaboo of all sex educators ...the pernicious Myth of the Stork. Before building my edifice, I must first clear the ground of its rubble and ruck.

Time and again I tried to break the ice...and faltered. But at the corner of 150th Street little Quackenbush himself solved the problem.

Instead of continuing along the street, he wheeled abruptly and marched me into a drug store.

"Uncle," he said curtly. "I don't understand you at all tonight. When we started out, you said we were after

two things,—a marshmallow sundae and some sex enlightenment. What about the sundae?"

I did not answer. A sudden inspiration had cleared up everything. I would use the marshmallow sundae as a stepping stone!

"One dish of plain ice cream," I said to the drug clerk. He scooped it out and placed it before me.

Plunging my hand into my pocket I drew out its contents. Three paper clips, an old eraser, a suspender button and some scraps of tobacco. Without saying a word, I dumped them all over the ice cream.

"Here, Quackenbush," I said as I shoved it before him. "Eat your marshmallow sundae."

The poor lad's jaw dropped. "Uncle!" he gasped. "That's not a marshmallow sundae. That's a paper clip, eraser and suspender button sundae!"

I beamed. He was catching on admirably. I took up a spoon and flipped the debris off the ice cream onto the floor.

"Look, Quackenbush," I said. "Before building a marshmallow sundae, we must first clear off all the rubble and ruck. And it's exactly the same with sex education. Before I can tell you anything at all, I must first clear your mind of its impediments. I refer, of course, to your belief in the stork."

"Put some marshmallow on this ice cream," Quackenbush said to the drug clerk. He turned to me. "You mean to say that the stork idea is rubble and ruck?"

"Exactly," I retorted. "And I can prove it."

"Never," asserted Quackenbush. "Daddy told me about the stork. Daddy is always right." He began to eat his sundae.

I had, of course, expected this stumbling block, and I was well prepared for it.

"Quackenbush," I said. "Let me tell you a story...a true story. It's about a man named Fepp...how he made up the stork story, and how sadly he came to regret it."

Quackenbush looked sceptical. Undaunted, I launched headlong into my narrative.

In some kiddies' minds the Stork and the Doctor are hopelessly garbled.

"Fepp was to blame for it all. Prior to Fepp all parents the world over were honest with their children. When a child asked, 'Daddy, where did I come from?' the parent hurled the truth at him straight from the shoulder. But not so Fepp.

"Fepp had a son named Albermarle. When little Albermarle—this was back in 1880—when little Albermarle climbed on his father's knee and asked that innocent question, Fepp did not wish to be bothered. For a moment he simply scowled. Then a slight commotion in the canary cage attracted his attention. He looked up. The Fepp canary was a longish sort of a bird and it gave him an idea. 'You were brought...oh you were brought by a stork, my child,' he said. Now let me read my paper.' "

"It was exactly the same when I asked my daddy," burst in Quackenbush. "Only my daddy said, 'Oh you were brought by a stork, my child. Now let me hang these awnings.' "

"Fepp thought no more about the matter," I went on, "but the stork stuck in poor little Albermarle's mind. Not only did he remember it, but he believed it implicitly. It was romantic, exciting! His pulse quickened when he thought of it...that

100,000,000 B.C. First pollen carried between daisies.

90,000,000 B.C. The jellyfish discovers he can reproduce himself merely by grunting.

2,080,000 B.C. Snails prove that two can live cheaper than one.

1,647,829 B.C. Experiments between reindeer and dachsund result in fiasco.

998,000 B.C. Elephant eggs prove impractical.

800,000 B.C. Last surviving female dodo turns down last surviving male.

720,000 B.C. Whale develops spout in order to keep cooler.

690,003 B.C. Hen lays solid china darning egg.

500,000 B.C. Mexican jumping bean's wife elopes, proving survival of the fittest.

400,000 B.C. The sole members of the Pitzu worm family meet when it's too late.

300,000 B.C. Near-sighted porcupine mistakes cactus for his girlfriend.

250,000 B.C. The first iceman.

ride in a bundle on the beak of a stork! He could feel the cool wind on his cheeks. He could hear the firm beat of the stork's sturdy wings. It tickled his fancy.

"Now it so happened that the Fepps lived on Staten Island. The Island at that time was but sparsely populated. There was only one school. In no time at all little Albermarle had spread the gospel of the stork to every last boy and girl. Their fancies too were tickled. Mr. Fepp's fable was acclaimed as a fact."

Quackenbush was starting his second sundae, but listening carefully all the time.

"Years passed," I continued. "The little boys and girls of Staten Island grew up and married. And what do you suppose happened?"

"I don't know," said Quackenbush. "What did happen?"

"Nothing at all," I retorted. "Absolutely nothing. That's just the trouble. The young folk simply hung around their houses waiting for storks. They fitted out nurseries. They bought layettes and cribs, bottles and bibs, safety pins, hobby horses, Kiddie Kars and colic cures. But no little strangers came to enjoy them. From 1899 to 1901 *not one single baby was born on the Island!*"

Quackenbush was listening intently. I felt I was getting my idea across.

"Old man Fepp had no grandchild. Nobody had any grandchild. The older generation grew frantic. If this nonsense were allowed to go on, what would become of poor Staten Island? They called repeatedly on their married children. They begged them to forget the stork—to listen to reason. Those cribs *could* be filled. Now why not be sensible? But the young folks laughed. Give the birds a chance. The past year had been windy and the storks had been unable to get across from the mainland.

"News of the Island's plight spread to New York. A publisher specializing in sex books sent over a ferry load of pamphlets. The young folks were incensed. They dressed up like Indians, swarmed aboard the ferry and threw the things into the harbor. Medical missionaries invaded Staten Island. They were tarred and feathered.

"Poor old Fepp! Everyone knew he had started it all. He was socially ostracized. People sent him accusing letters. He couldn't sleep nights. Finally, able to bear it no longer, he determined to right the wrong he had wrought. He talked it over with his wife, and they hit on a plan. The first step in their plan was to have another baby!

"The Fepps by this time were going on seventy...but where there's a will there's a way, and after a certain passage of time they ran an ad in the local paper. All young folks in town were asked to gather before their veranda on a certain Tuesday morning.

"When the crowd was assembled, Mr. Fepp stepped out and addressed them as follows:

"'Ladies and gentleman,' he announced simply, 'Mrs. Fepp and I are about to receive a visit from a little stranger, or, baby!'

"A murmer ran through the assemblage. A murmur of astonishment....

"'At last!' yelled the young folks. 'The stork has come back to Staten Island!'

"But Fepp held up his hand for silence. He shook his head sternly. 'I want you to understand,' he said, 'that when I started that stork story back in '80 I was talking through my

hat. I have eaten those words many times since. But you still persist in believing. You must be *forced* to see the light.

"'At great personal sacrifice to us both, Mrs. Fepp and I are having this new baby as a final appeal to your reason. We are now going to prove that no stork has anything whatever to do with it. Follow me.'

"So saying, he took his wife's arm. She smiled at him bravely. Heading the bewildered procession, they made their way straight to the dock. A special ferry lay bobbing at its moorings, and the entire crowd, openmouthed with wonder, followed them up the gangplank.

"'To the Brooklyn Bridge!' Fepp ordered the pilot. And off they sailed.

"Half an hour later the same astonished assemblage was standing on the bridge, curiously examining a strange contraption. It was a huge packing case sort of affair, about ten feet high by fifteen feet broad.

"'There are beds in it!' exclaimed one.

"'And a kitchenette!' exclaimed another.

"'And look there! Oxygen tanks! Whatever is it for...?'

"'You'll see,' said Fepp. He made a stirrup of his hands. His wife put her foot in it. With surpassing agility he hoisted her up and over the side. Without another word Fepp clambered in after. Assistants stepped up and clamped down the lid. The crate was sealed with tinfoil and wax, and the Hon. J.J. Drouberhannus, the then Police Commissioner of New York City, chained and padlocked it securely."

"Good gracious, what then?" demanded Quackenbush. His flushed little face was all smeared with marshmallow.

"Well," I said. "A huge weight was attached to the box. A crew of workmen stepped up, pushed the thing up to the edge of the bridge and shoved it off into space! Down it tumbled. Splash!—and the crate disappeared! Commissioner Drouberhannus then beckoned the flabbergasted crowd to follow him. They all got into horse cars and rode to the Guarantee Trust Co. There, in the presence of all, he placed the key to the padlock in Safe Deposit Box No. 847.

"For three days and nights the Staten Islanders were entertained on the mainland...at Fepp's expense. Theatres, dinners, nice suites at a hotel. But on the morning of the fourth day, they were all bundled out early and packed into horse cars again. Led by Goldman's Band, the cavalcade wound its way down to the Brooklyn Bridge.

"Grappling irons were lowered into the water. The box was located. Up it was dragged. As it lay dripping on the bridge, up stepped the Hon. J. J. Grimalken, the then Mayor of New York. The Police Commissioner handed him the padlock key. He stripped off the seals. Thousands craned their necks breathlessly as the lid was lifted!

"And lo and behold! Not only were Mr. and Mrs. Fepp safe and sound inside...*but three brand new little Fepps as well!*

"Cheers rent the air. Hats went skyward. Everyone agreed that even if it *were* possible for *one* stork to get into that box, it was absolutely unthinkable that it had been penetrated by *three.*

"Fepp had redeemed himself. He had killed the lie that he had so thoughtlessly started. The young folks rushed for the Staten Island ferry. The next year their birth rate was simply tremendous."

I looked down at little Quackenbush to determine his reaction. Only one glance was needed to tell me I had won my point. From now on I knew that the stork was quashed.

"Uncle," he said. "You have cleared my mind of its rubble and ruck. I thank you. But now you must tell me, where *do* babies come from?"

I leaned down and whispered something into his ear.

Quackenbush laughed. "That's more ridiculous than the stork," he said, "You'll have *some* time convincing me of that."

I smiled quietly. I paid for his ten marshmallow sundaes and we strode from the store. Linking arms, we started back home. Tomorrow evening I would start building my edifice.

CHAPTER II
An Introduction to Anatomy

I had mapped out the course for our second walk with care and deliberation. The brightly lighted streets of the Bronx proper were scarcely the setting I wanted tonight. I needed the isolation of a darker district. Tonight I was loaded with dynamite that had best be set off in seclusion. Far, far away from the beaten path, little Quackenbush and I were picking our way in silence along Harlem River.

I peered sharply up and down the street. It was entirely deserted.

"Come, Quackenbush," I whispered quickly. I grasped his hand and drew him after me through a break in the fence...into the foreboding dimness of a vacant lot. Here I could tell him and not be seen blushing.

The moon shone eerily down upon a desolate scene...diffusing a strange half light over the piles of broken plaster and brick. Tin cans gleamed stealthily. From a tenement in the far distance came the sound of someone hanging pictures.

My mind jumped suddenly into the future. Some night little Quackenbush, too, would be hanging pictures. The first sweet night of his

"There they stood...exactly as they had been created!"

all their details...the anatomical structures of Man and Woman! There they stood...Man and Woman, exactly as they had been created! They were frank and shameless, *clad only in bathing suits!*

I paused and wiped the cold perspiration from my brow. I looked at Quackenbush. His face was radiant. His eyes gleamed feverishly.

For a moment I was afraid. I half regretted the daring bathing suit idea. Perhaps I should have drawn them in half buttoned ulsters. But then I realized it *had* to be bathing suits. Science may be shocking, but it *has* to be factual.

"There you are!" I announced, with a gesture. "There you are... Man and Woman...Woman and Man...get the idea?"

"Gee!" whistled little Quackenbush.

From the tenement in the distance came the soft whirring purr of a vacuum sweeper. The picture hanging had been completed, and the happy young wife was cleaning up the plaster.

Little Quackenbush had turned away from the picture. He was looking at me, puzzled. "Which is the woman?" he asked simply.

A feeling of futility welled into my throat! I had thought he had got it. But evidently it had not been the subject matter, but my skill that had thrilled him.

"Please look at them again," I said as calmly as I could. "Take a good long look."

Quackenbush stared at them intently.

"Oh, come now," he begged finally. "Give me a hint."

"Quackenbush," I asked. "Did you ever see a woman with an Adam's apple?"

"Adam's *what?*" The lad gaped at me, completely bewildered.

"Good heavens, Quackenbush!

married life. Many wedding guests would have given him pictures and he would be hanging them on the walls of his love nest with his bride standing by blushingly, holding the ladder.

"Little Quackenbush, old man," I said in a voice that was strangely husky. "There's much more to sex than you'd ever suspect. Last night you thought we accomplished a lot. But we only tore down the stork." I bent down and whispered into his ear. "What I mean to say is, tonight's subject is Comparative Anatomy!"

The lad stared at me as if transfixed. I knew he hadn't the faintest idea what I meant, yet there was something about the phrase that struck him with awe. I faltered. Maybe I shouldn't. Perhaps I should only be talking about flowers!

But the die was cast. There was no time to turn back. With grim resolution I whipped a piece of chalk from my pocket. I stepped to the fence. Quackenbush gaped. On the boards of the fence, in a few succinct, truthtelling strokes I drew, complete in

You don't mean they've never even told you about Adam's apples?"

"Adam's apples?" Quackenbush thought back over his education. "Never, uncle. What are they like?"

"It's like this," I said, "Take your papa and mama...no..." I thought of something more striking. The functional analysis of the Adam's apple might better be delineated by a true tale from Evolution.

"Don't take your papa and mama," I corrected myself. "Take a couple of snails. You are one of the first snails of history. Snails are absolutely new on the earth, and so far you have no trace of an Adam's apple. But anyhow you are a young male snail. A lonely male snail wandering listlessly about the pampas in search of a mate. The search seems endless. You become discouraged, but your masculine instincts egg you onward and onward, until finally, just as you are about to give up in despair, you wander into a setting that makes your heart leap! It is a veritable Eden of snails...dozens of them, yes, hundreds of them disporting themselves all over the greensward. Then what do you do?"

"Very simple," said Quackenbush. "I just walk up and propose to one."

"Ahhh! But you're wrong," I corrected him. "It's not that easy at all. You can't propose. It's impossible. All you can do is stand there perplexed. Snails' faces, you know, are all exactly the same, and only their heads stick out of their shells. You're stumped for fair. You can't tell the girls from the boys!"

Quackenbush whistled. "This *is* a fix," he said and shook his head.

"A fix indeed...especially when you realize that you *have* to get married. If you don't get married, that's the end of your race."

"It worries me terribly, Uncle." He grew very uneasy.

"Good!" I grinned. "Worry away.

The more worry the better, in fact. Nature has a remedy for every dilemma...and in this case the remedy is nothing more than worry. Do you know what happens when you start to worry?"

A light dawned on Quackenbush's brow.

"I know! I know!" he fairly bubbled. "I get a lump in my throat...the ADAM'S APPLE!"

A thrill of pleasure ran through me. My pupil was sparking beautifully. "Wonderful!" I ejaculated. "And then the girl snails, seeing this signal..."

"...all pounce upon me, and my troubles are over forever! Now I see *everything*. Man and woman... woman and man...there *is* a difference."

From the apartment in the far distance came the noise of new hammering. The bride and groom were rehanging their pictures.

I regarded little Quackenbush and smiled quietly. I had laid another brick in the Temple of his Future Happiness.

CHAPTER III
What About Birth Control?

It was a velvety evening—lissom, yet invigorating withal. Little Quackenbush was perched gingerly upon the handlebars of my bicycle, a fragrant balsam pillow beneath his little haunches, and as I pedalled sinuously along the upper reaches of Broadway, we hummed the sex-

tette from Lucia in a manner that made passersby perk up their ears.

The world was friendly. Chinese laundrymen waved flatirons affectionately from the wide open doors of their shops. A brace of airedales kept pace with our bicycle, nipping playfully at our tires. And when we swung around the corner of 198th Street and crashed into a push cart, the proprietor merely grinned and handed us each a tangerine.

Beyond a few superficial contusions, neither of us was the worse for the shakeup. Still singing, we lugged the mangled bike to a nearby repair shop.

The damage was not serious. So Quackenbush and I sat down on the curbstone to wait while they fixed it.

"By the by, uncle," said Quackenbush. "What is birth control?"

I lighted my meerschaum slowly, angling for time. This was something the lad ought to know, but at the same time it had to be handled with care.

"That question," I answered finally, "can best be explained if you will come with me for a short stroll in Switzerland."

Quackenbush looked puzzled.

"I mean a metaphorical stroll," I explained. "We're really not going to budge from this curbing."

Quackenbush looked relieved.

"The particular spot we shall seek out in Switzerland," I continued, "is the Vierwaldstaeter-See; 'See' meaning lake, and 'Vierwaldstaeter' meaning Vierwaldstaeter."

Quackenbush was nibbling at some *petits fours* he had found in his pocket, but was hanging intently on my every word.

"It is on the shores of this Vierwaldstaeter-See that the curious Grimalkenvogels build their nests in apple trees. Let us climb one at random and take a peek inside."

"That wouldn't be playing cricket with the Grimalkenvogels," objected Quackenbush. That was just

like Quackenbush...always the sportsman.

"Nevertheless," I swept on, "we *will* look inside. The parent birds are out, and what do we find but three baby Grimalkenvogels.

"We come down from there and climb another tree. Looking into this nest, we *again* find *three* urchins. And so we could go on, tree after tree, day after day...and never would we find a nest containing more than three Grimalkenvogel offsprings."

"Is *that* remarkable?" challenged Quackenbush, his interest lagging.

"It's more than that, young man," I said, "Just contrast these Grimalkenvogels with the people who live on your own street, and you'll admit that it's genius. Who lives next door to you? The Cadwallers. How many little Cadwallers are there?"

"Four little Cadwallers," said Quackenbush. "And I can lick every one."

"Take the Mulrooneys...*seven* little Mulrooneys! And how about Mr. Popolopolis who sells ice cream at the corner? He has *fifteen* little Popolopolises!"

And I hear there's another one due in September," added Quackenbush.

"And so it goes," I said. "Every house has more than the one before...the number growing more staggering as you get nearer the railroad tracks."

"I guess," admitted Quackenbush, "that I'll have to take off my hat to the birds at that. What's the answer?"

"The answer," I said, "is that necessity is the mother of invention. The Grimalkenvogels *have* to keep down their numbers. If they didn't there wouldn't be enough beetles to eat."

"Why?"

"Because they eat gnats , and the gnats practice birth control. Now just how the beetles and gnats manage, nobody knows. But we do know about the Grimalkenvogels."

"Do they control their eggs?" asked Quackenbush skeptically.

"No," I said. "Egg control is something they haven't yet mastered. A Mama Grimalkenvogel may lay a many as forty-five eggs in one short egg season."

"I know," ventured Quackenbush. "She simply goes out and hides her surplus eggage."

"No," I contradicted. "It's not so simple. And that's because Papa Grimalkenvogel won't allow it. The male of the species is a vain sort of chap. Nothing would please *him* more than having a whole flock of

*No sort of a gift for
a young adolescent*

children just so he could gloat it over the other Papa Grimalkenvogels. So he trails his wife incessantly. If she hides an egg, he ferrets it out and brings it back home."

"I give up." Quackenbush was stumped. "How does she do it?"

"Very ingeniously. *Very* ingeniously." I smiled. "Whenever Mama G'fogel feels an egg coming on, she quits the nest and makes for the nearest golf course. Papa G'fogel, of course, tags right along after.

"Her arrival at the first tee is a marvel of scientific timing. A second too soon or a second too late and the whole job would be botched. A very genius for detail, the expectant Grimalkeness *always* passes over the caddy house at the very instant a golfer is sticking his little wooden tee in the ground. When he places his golf ball on the tee, she is forty feet off. At five feet, he is hauling off with his driver to sock it. And then comes a demonstration of mental and muscular coordination that will never cease to amaze the world of science."

Quackenbush was listening as if transfixed. His hands full of *petites fours* seemed frozen, halfway to his mouth.

"The club is descending....But even faster than the club, the Grimalkenvogel is descending. Down she zooms! A well aimed flick of her beak, and the golf ball is off the tee. Another well aimed flick...and her brand new egg is sitting there in its place. And..."

"...BANGO!" shouted the excited Quackenbush.

"Not exactly, my lad," I said. "SQUISHO! is more like it. Anyway, the egg may be dubbed, it may be hooked or sliced...but any old shot, no matter how dufferish, is Birth Control to a Grimalkenvogel."

I puffed on my meerschaum for a

moment to give Quackenbush a chance to mull it all over. He mulled. Finally he spoke.

"Uncle," he said thoughtfully. "That's all very well for a Grimalkenvogel...but how in heaven's name could Mrs. Cadwaller, Mrs. Mulrooney, and Mrs. Popolopolis...?"

"Your bike's fixed now," broke in a voice from behind us. A more opportune bicycle fixing I could not imagine. I paid the bill, hoisted little Quackenbush onto the handlebars and pedalled off home.

CHAPTER IV

Tonight was the last of our Nature Walk Talks. Nightly for eight instructive weeks little Quackenbush had been, so to speak, like a bicycle tire which I had been filling with puncture-proofing *(sane sex enlightenment)*. One more treatment and this tire could safely withstand the buffets of the rough roads of Adolescence with never a fear of a blowout.

We were seated, somewhat uncomfortably, twenty feet above Carl Schurz Park upon the limb of an oak tree. It had not been my original intention to hold this final sex lecture in an oak tree, but as it was the last one, I had yielded to Quackenbush's whim. Young spring moonbeams filtered lambently through the leafy verdure and the air was brisk with the compelling scent of buttered popcorn.

"Quackenbush, old man," I opened up. "We have already covered the main bulk of sex. But there must be in your mind one or two questions. Ask me anything, and I'll clear it up."

"What's in that bundle, then?" he demanded, quick as a flash. All evening long he had been eyeing the mysterious package I carried under my arm.

I winked. "That's a surprise...for later. Come now, a real question.

Does your Tree of Life need a Davey tree surgeon?

Something puzzling you about, say...ladies?"

"Not a thing."

"About...uh...gentlemen?"

"I guess not."

"Well, then, perhaps something about ladies *and* gentlemen?"

Quackenbush suddenly brightened.

"I know a question," he said. "About the tree that falls in the forest. If there's nobody there to hear it, is there any noise anyhow?"

"Tree noises, Quackenbush," I answered quietly, "have no significance sexually." Quackenbush looked crestfallen.

"Some kinds of noises," I reassured him, *are* pretty sexy. I could tell you, for instance, something about mating calls."

Sex, Sex, everywhere Sex! Even ostriches hiding their heads have ulterior motives.

"Try and make it funny," said Quackenbush.

"Unfortunately," I shook my head, "the particular mating call I have in mind falls on the side of tragedy.

"I want you to think about the place you spent last summer...the cottage at the sea shore. Remember the fun...the swimming, the boating and the marshmallow toasts? That gay sandy beach to you was a symbol of carefree joy. And yet, scarcely a foot beneath the surface of that sand, there lay stark tragedy."

"Go on with you, uncle." laughed Quackenbush, slapping an oak leaf disparagingly.

"Really," I insisted. "I refer to the tragedy of the poor razor back clams. Did you know that in the razor back clam world, old man, sex is apportioned rather unfairly? There is only one male (or papa)

razor back clam to every fifteen of the mama variety."

"What of it?" sniffed Quackenbush. "When I was in kindergarten, there was only me and Freddy Napier as against *seventeen* of the mama variety, not counting Miss Schneeloch, the teacher."

"But your responsibilities were not similar," I said. "None of those

A NOTE ON MATERNITY
The most obvious manifestation of Maternity is Cradles, so probably the best way to explain cradles is by recourse to that glorious old game, The Cradle of the Cat. Above, Cat's Cradle, position A.

seventeen little girls had mating calls."

"Miss Schneeloch was pretty good at imitating an owl."

"That wouldn't be a mating call," I corrected. "Now, if Miss Schneeloch imitated a Miss Schneeloch..."

I looked down suddenly to catch Quackenbush slipping the string off my bundle. I slapped his fingers smartly.

"I told you, the surprise comes later. The first thing you know you'll knock it out of the tree. Come on now...back to the clams and their mating calls.

"A mating call works somewhat on the same principle as a locomotive whistle. Only *male* clams have mating calls as only the *engines* have whistles. Now, the razor back clam is like a locomotive. Only instead of steaming along on tracks, he sits

46

THE LAW OF INHERITANCE OF ACQUIRED CHARACTERISTICS

In 1910, a cross-eyed elephant was married to a wall-eyed elephant to prove that their children's eyes would be straight. Unfortunately, the couple died without issue.

quietly in the mud in front of your cottage. In the old days the male clam led an ideal existence. All day long he would sit in the sand, half dozing and lolling. Finally, along about nine in the evening, he would begin to smile. 'What else is there a clam can do besides dozing and lolling?' he would ask himself. And then he would remember his mating call.

"His pulse would quicken...

pounding like drums in his swooning little ears. Giddy with desire, the flushed little clam would protrude his head from his shell. His lips would tremble as they touched the soft sand, and the waters lapped seductively about his gills. Every fibre of his sleek body would get behind his lungs and push... and..."

"I know!" shouted Quackenbush, and he hooted shrilly like a steam

locomotive.

"That's the general idea," I smiled. "But he really goes like this..." Bending down close to his ear, I breathed, hardly audibly, *"OOOOOgie! OOOOOOOOOgie!"*

"Gosh!" gasped Quackenbush. "What that mustn't do to a mama kind of a clam!"

"Exactly," I said. "The moment they hear this, they drop whatever they're doing like a hot cake and

Sex Laws Are Illogical

The Patagonian Hepatica (magnified 800 times) can become a father at the age of three minutes.
His cousin, the Chilean Hepatica, is forced to wait all of 63 years.

burrow through the mud, post haste in his direction."

"And there are fifteen to his one," gulped Quackenbush. "Say, I thought you said this story was tragic?"

"And so it is," I shook my head. "I have been describing the *ideal* clam's life as it *used to be*. But to-day, if you were to dig one up, you'd find him with deep mournful circles etched under his eyes. Why? His life has been ruined by the ruthless march of modern science; specifically, by the radio! You, Quackenbush, you are to blame along with the other summer cottagers. You rise, say, at eight, and the first thing you do is turn on the radio."

"That's right," confessed Quackenbush, looking guilty.

"Remember...at 8 a.m. the poor old clam is still fast asleep...and well deserves to be. It's scarely an hour since his visitors left him. Now, let me ask you, what piece of music,

nine times out of ten, is sure to come over the air?"

"Why...*The Last Roundup*... naturally." Quackenbush stiffened like a ramrod. "Heavens, Uncle!...'*Git along little Dogie!* ...DOGIE...OOOOOOOOgie'... Practically the razor back clam's mating call!"

Quackenbush whipped out a scrap of paper and did some frantic arithmetic. "Lord!" he blushed. "I play that piece perhaps eighty-seven times a day....Eighty-seven mating calls times fifteen mama clams...phew!...1,305!"

I regarded little Quackenbush's features closely. A new born sophistication glowed from his eyes. He knew ALL. The nature walks were at an end.

"Here, old man," I said simply, handing him my bundle. "Take this...you have earned it."

With scarcely a trace of his former

boyishness, Quackenbush undid the knot, gravely and calmly. The last wrapping fell off and fluttered to the ground. Quackenbush gaped ...stunned by the significance of what he beheld.

It was the *summun bonum* of the Baker's Art. A shining Taj Mahal of shimmering frosting vibrated in his grasp. Across the top, deftly inscribed in strawberry icing, read the legend, "The Little Quackenbush Goodby Boyhood, Hello Adolescence Memorial Layer Cake!"

"Let's go home and cut a hunk!" he whispered in a voice strangely awed. And he slid down the tree trunk.

As I slid down after him, I smiled quietly. I was thinking of the real surprise that awaited him when he cut it. For the interior of the cake was hollow. In an ingenious little cache within nestled Quackenbush's First Long Trousers...suspenders and all.

48

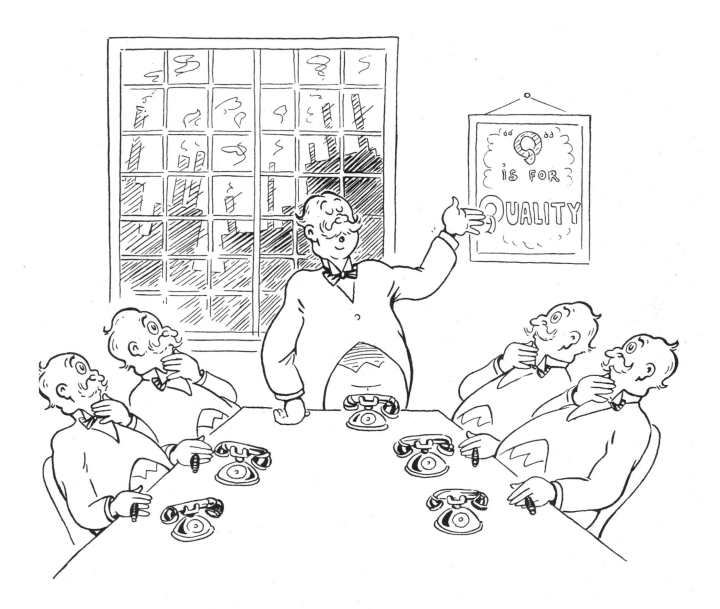

QUALITY

Once upon a time the great Chairman of the Board of a great concern called his directors together and said, "I believe, gentlemen, that lately we have become too concerned with making profits."

For a moment the directors pondered, and then spoke back, "B.J., you are dead right!"

"So I move," said the Chairman, "that henceforth we concern ourselves only with quality *...cost what it may!*"

The motion, naturally, was carried unanimously, in a chorus of huzzahs.

Impatient to put this new policy into immediate operation, the directors seized their telephones and called the company's many purchasing agents who were scattered far and wide in every nook and cranny of the world.

"From now on, boys," they instructed them, "only the super-best quality in raw materials, and shucks with the costs!"

"I'll get you quality!" shouted the purchasing agent in Greenland. And hanging up the receiver, he fitted out an Arctic schooner and raced straight for the Pole. His expedition set the company back $300,000.00, but no one objected. For he brought back the choicest bird of the Arctic...the rare Yellow-Green Penguin, the nightingale of the northlands.

"Hurrah for Quality, cost what it may!" shouted the purchasing agent in Africa. And hanging up his receiver he fitted out an expedition of 300 natives and plunged head- long into the Belgian Congo. 298 of his men perished of fever . . . but he brought back the rarest bird of the jungle, the Gibney Grackle. The widows were handsomely pensioned.

Inspired by the Challenge of Quality, the Chilean agent scaled every windswept crag in the Andes, in pursuit of the elusive Giant White-Tuffed Condor. And though he lost three fingers to frostbite and a thumb to the Condor, he thought nothing of it. All of his thoughts were centered on Quality. Truly he had given the full measure of devotion.

At Khartoum, the Egyptian agent called Sheik Ali Ben Giseh, greatest of desert bird hunters, into his office. "I know you're a busy man," he said. "And I know the task is well nigh impossible. But here's ten thousand pounds in gold. Go out and get me a Sudanese Humming Bird." (Practically extinct since the days of the Pharaohs—a lucky thing for the date crop.)

From swamps in Malaya, from plateaus in Tibet, the agents phoned to New York, "Your rare birds are ready. We have done nothing but our simple duty."

And each morning a tri-motored bird-transport took off from New York, dashed here and there to all parts of the globe and whisked back the costly creatures in perfect condition.

Planeload after planeload they were assembled in a warehouse, and when there were 2,000 the directors examined them minutely in batches of 18. Then came an historic moment:

One afternoon, after months of careful analysis, the Chairman of the Board tapped an Andulasian Feeney Fowl lightly on the chest, saying, "This chap, gentlemen, I am sure is he!"

Amid the cheers of the directors, the Andulasian Feeney Fowl was rushed to the Clipping Room. And, under the most antiseptic conditions, and with the aid of a local anesthetic, the Master Clipper clipped exactly one inch and three quarters from the tip of his tail.

They glued this feather to the end of one of those Blower Things that people play with at parties (for such was the company's product).

And due to the super-quality of this particular feather, the man who eventually bought the blower had a simply marvelous time.

Dr. Seuss's
Little Educational Charts

Ough! Ough!

Or Why I Believe in Simplified Spelling

"The Tough Coughs As He Ploughs the Dough"
It was forty-five years ago, when I first came to America as a young Roumanian student of divinity, that I first met the evils of the *"ough words."* Strolling one day in the country with my fellow students, I saw a tough, coughing as he ploughed a field which (being quite nearsighted) I mistook for pie dough. Assuming that all *ough words* were pronounced the same, I casually remarked, "The tuff cuffs as he pluffs the duff!" "Sacrilege!" shrieked my devout companions. "He is cursing in Roumanian!" I was expelled from the school.

"Mr. Hough, Your Bough is in the Trough"
The ministry being closed to me, I then got a job as a chore boy on the farm of an eccentric Mr. Hough, who happened to spend most of his time in the bough of a tree overhanging a trough. I was watering a colt one morning when I noticed that Mr. Hough's weight had forced the bough down into the water. "Mr. Hoo!" I shouted, "Your Boo is in the Troo!" Thinking I was speaking lightly of his wife, Mr. Hough fired me on the spot.

"Enough! Enough! I'm Through!"
So I drifted into the prize ring. But here again the curse of the *oughs* undid me. One night at the Garden, I was receiving an unmerciful trouncing from a mauler twice my size. Near the end of the sixth round I could stand it no longer. I raised my feeble hand in surrender. "Eno! Eno!" I gulped. "I'm thruff!" "Insults like that I take from no man!" bellowed my opponent, and he slugged me into a coma! Something snapped!...a maddening flash...and all became black. Fifteen years later I awoke to find myself the father of three homely daughters named Xough, Yough and Zough. I had become a thorough-going Augho-maniac.

Punish Your Offspring Scientifically!

New Notes on Child Chastisement

The gruesome situation above illustrates the most heartless practice known to the modern family—the angry father having grabbed up his boy *by the nape of the neck.* He does not realize that young boys' napes are easily wrenched out of shape. A scientific father always grabs up his son by the *scruff.*

Mr. and Mrs. L. Pffeff are having that timeworn old argument—the *boxing* of the ears *vs.* the *cuffing* of the ears. In the eyes of modern science, however, neither method is good. Authorities now recommend *buffing* the ears, a milder form of punishment easily administered with the aid of a pair of old buttonhole-shears.

Forty or fifty years ago, when I was a boy, I swore like a trooper. Although my mother continually washed out my mouth with soap and water, today I swear worse than ever. Mother's mistake was in using *only one kind of soap!* Modern mothers realize that every single curse word must be treated individually with a special brand of suds.

Making Our Daughters Less Irritating

**Three Bad Girlish Habits that are
Now Easily Rectified**

The Pout Extinguisher

Parents who cannot keep their little girls from pouting will find this device a god-send. After this apparatus has been securely fastened to daughter's head by a good reliable blacksmith, let her go ahead and pout if she dare! Such an action will immediately upset the balance of the delicate machinery, releasing the mallet...and socko...the little rascal gets such a smart rap in the chops that she will not be able to pout again for many a day to come.

Overcoming the Face-Making Menace

"Lucille, naughty child, stop making those horrible faces! *Suppose your pan should freeze that way, then wouldn't you be sorry?*" How many times a day a parent has to shout this. A portable child-sized fridgidaire is now on the market, which you can clap down over the child at the height of a face-making orgy. Instantaneously her face *actually is frozen that way!* After she has had to wear it around like that for a week or two, she will jolly well beg you to thaw it out, and will promise to give up the habit forever.

The Instantaneous It-Machine

If there's anything annoying about a group of girls playing tag, it's to see their *Eeeny, meeny, miny, mo* method of counting out to see who'll be It. Such nonsensical chatter is no longer necessary, thanks to this remarkable device. The contestants are lined up in a row, each one under a small nest-like container. Four of these containers hold hen's eggs, while the fifth secretes an ordinary billiard ball. When these objects are dropped onto the young ladies' heads, the four who have been struck by eggs scamper away into hiding. The fifth, struck by the billiard ball, lingers behind, detained by temporary unconsciousness. She is the one who is It.

My Three Best Tricks and How I Do Them.

By the World-Famed Magician, Yogi Seuss

Some time ago the great Yogi issued a challenge to the chief of police of this city to sew him, handcuffed, into a burlap bag, lock him inside of a ten-inch steel safe, and hurl him from the Brooklyn Bridge into the river. This was done. After waiting three hours for the Yogi to escape and rise to the surface, the chief pronounced the attempt a failure. But on his return to his office he was greatly astonished to find the great magician already there, calmly playing at jack stones with the police matron. The suspicious chief investigated. When the safe was hauled out of the river, it was found to contain a *second* Yogi, the real Yogi having bribed him to take his place. The chief immediately challenged the man to an even sterner test of his powers. The Yogi is now in a padded cell in Sing Sing, having the rest of his life to figure out an exit.

The Multiplying-Olive Pips

During my student days in a jungle village of India, I was one day invited to the funeral of the local Mhwambi. None of the carelessly selected guests were at all well acquainted, and had I not been quick to take the situation in hand, the whole party would have gone on the rocks. Collecting the spectators in a clubby little knot, I stepped up to the widow. "Why, Mrs. Mhwambi!" I exclaimed in a mock-scandalized voice. "What a time for *you,* of all people, to have *olive pips* in your ears!" I then plucked more pips from the other guests, and then the proper atmosphere of conviviality having been established, I plucked one or two from the deceased. This brought the house down.

"Cow-out of Pocket"

This one is a riot, and I introduce it like this. "Will some gent oblige me by stepping up onto the platform?" I ask. "Any one at all...you, for instance." And I beckon to the man in seat J-22. Once he comes up it is a relatively simple matter to extract the cow from his upper right-hand vest pocket. *"You old milk sop, you!"* is the humorous line with which I accompany the action.

Explanation: The hard part of the trick is always done before the show by my reliable cow-man, Halsey. He waits in ambush at the box office for someone to purchase seat J-22. This done, he has an "accidental" way of brushing up against him and "planting" the cow.

Floating-Damosel-and Kitten

In this exhibition a high caste Hindu maiden and a black tom cat lie flat on their backs side by side on the stage. After placing them in a trance, I make a few mystic passes over their bodies, and lo! still horizontal, they rise slowly into the air, where they float about loosely.

Explanation: Floating in the air is really no harder than floating in water. In learning, the pupil is held aloft by waterwings blown up with helium gas. As soon as the beginner has mastered the rudiments, the waterwings may be dispensed with entirely.

A Few Subtle Pleasures

Devised for Those Who Have Wearied of the Commonplace

For Seamsters in Retirement
When sewing on cloth has begun to lose its enchantment, what you need is a change. Amuse yourself by sewing brown trouser buttons on to a vanilla ice cream cone.

Bobbing for Pineapples
A Hallowe'en diversion for firemen who suffer from ennui.

Gargling on Camel-Back
(For Red-Headed Second Cousins)
How soon one tires of gargling by his lonesome in the narrow confines of his bathroom! But just try it on the vast expanse of the desert on the back of a prancing camel! The old sport will take on new and delightful proportions with which you will never be bored.

The *Real* Way to Take Snuff
This one is a thriller to even the most *blasé*. Pose yourself, ankle deep, in an 85-degree foot bath. Give the signal for the masked trio to strike up *Hearts and Flowers*—and inhale deeply.

The Strangest Game I Ever Refereed
By Dr. Theophrastus Seuss

As I think back over the mellowing years, I can remember refereeing no game that intrigued me more than the *Oahspe High School-Harvard* clash of 1889. Of the actual plays themselves I remember but little. It is my pleasure, rather, to recall the uncanny feeling that came over me when I discovered that every last player on the high school eleven was named Seuss. That *was* a thrill! But the thing that I never quite could get over was that every Harvard gladiator bore the name of Seuss as well! Twenty-three Seusses, and not one of us related! I am inclined to put this down to coincidence.

The Oahspe High School "Indomitables"

Reading left to right from rear—*Standbridge Seuss, Hasselrig Seuss, J. Basset Seuss, Hough Seuss, Capt. "Whoobub" Seuss, Kraydock Seuss, Osney Seuss, Flossglouscester Seuss, Sikh Seuss, Russwynn Seuss, and N. Seuss.*

The line-up:

Oahspe High School			*Harvard*
Seuss	L.	E.	Seuss
Seuss	L.	T.	Seuss
Seuss	L.	G.	Seuss
Seuss	C.		Seuss
Seuss	R.	G.	Suess
Seuss	R.	T.	Seuss
Seuss	R.	E.	Seuss
Seuss	Q.	B.	Seuss
Seuss	L.	H.	Seuss
Seuss	R.	H.	Seuss
Seuss	F.	B.	Seuss

Touchdowns—Seuss, Seuss, Suess 2, Seuss, Seuss, Seuss.
Points after touchdown—Seuss, Seuss.
Substitutions—Oahspe High School: Seuss for Seuss.
 Harvard: Seuss for Seuss, Seuss for Seuss, Seuss for Seuss, Seuss for Seuss.

A Thrilling Break

Only once was the Oahspe goal line threatened by the Seussmen from Cambridge. This happened when a forward pass, Seuss to Seuss, was intercepted by Seuss. On the next play, however, a fumble by Seuss was recovered by Seuss and passed to Seuss.

Going Abroad?

Let the Seuss Travel Bureau Arrange your Transportation!

For Economy, Travel on a Budget!
This summer, hundreds of American families will be cantering through Europe on reliable Budgets furnished by Seuss. You, too, may enjoy the Old World's wonders on Budgetback! Drop in at our kennels and have a trial spin!

Want to Work Your Way Across?
Let us get you a job as chief polisher on one of the big aerial shoe-shining parlors flying between New York and le Havre! The pilot, a Princeton man, is most anxious to get a Harvard man to fill this responsible post.

Afraid of Seasickness?
See Seuss!
Clients frequently come to us and say, "I'd like to go abroad, but I'm, oh, such a wretched sailor." *Always resourceful, we send these people across in something else besides a ship!* At a ridiculously small charge, we recently sent a gentleman to France in his own dumb-waiter. The idea that boats are necessary is downright old-fashioned.

A Critical Survey of the Custom of Hat-Doffing

A glimpse at its Ancient Origin, and its Highly Specialized Character Today

Hat-doffing, according to the historian Vjalarius, was first practiced by a fourteenth century Gascon noble, the Duke deDoff. The Duke, it seems, was frightfully keen on the ladies, the sight of one alone sufficing to make his temperature mount unbelievably. Hat-doffing was the method he invented to allow the steam to escape from his armor.

When the International Hat-Doffing Rules Commitee met last month, the best thing they did was to revise old Rule Number 196, which deals with the etiquette of doffing a top hat while carrying a cane, an umbrella, a bust of Catullus and a watermelon. Condemning the old way as too clumsy, the committee now allows you to balance the watermelon on your left calf.

Young men appearing socially for the first time are always harassed by the problem, "How high shall I doff my hat, and at precicely what angle?" In Finland, therefore, parents always send their sons to hat-doffing schools. As the Finns are notoriously poor mathematicians, the measurements and angles are graphically demonstrated in terms of well-known fish.

Some New and Better Superstitions!

No longer held in awe by the outworn humbug of our old superstitions, the public must now be taught an entirely new set of uncanny beliefs.

Everyone now admits that four-leaf clovers as luck-bringers are impotent. Our revised superstitious system therefore advises the old discouraged clover seekers to go out hunting for bullfiddle "D" strings that have a taste subtly but unmistakably reminiscent of sassafras tea in which a lentil had been dunked.

Ever since these new superstitions went into effect (on midnight Nov. 19) business men have been watching their step lest they shake hands with a person in front of a screen through which a cat's head is protruding and behind which there is boomerang autographing going on. One who does this is tempting the fates and his business will rapidly slump from medium to only so-so.

Retaining the best features of the old beliefs, the revised superstitions make much use of mystic highsigns to ward off evil fortune. As a safeguard against bad luck at jack straws, ears should be held onto as shown above whenever you pass between a ventriloquist wearing a thumb ring and a book case containing a number of miniature cardboard igloos.

According to our new code, youths and maidens should conscientiously avoid kissing in the prescence of two Pekineses and a man bearing a makeshift escutcheon, esoterically emblazoned. The kiss under such conditions means that your children will one day suffer acutely from a paucity of stencils.

A Lesson In Connoisseurship.

Some glimpses of our nation's most outstanding collectors, printed as an inspiration to all young amateurs interested in the hobby of accumulation.

Two Queen Victoria Collections Merge!

At last, after years of red tape and complicated negotiations, the two most astounding collections of Victoriana have been consolidated under the same roof. The Dr. Dorman d'Greb Broab collection (left) consists of a list of every kind of fruit that Queen Victoria never carried in a white muslin bag slung jauntily over her left shoulder. To the right, Dr. Phineas Autumn's collection faultlessly enumerates the carpenter's tools that were not in that bag any more than the fruit.

30,000,000 Autographs In 116 Days!

Such is the inspiring record of Raoul Phoebethron. Collector Phoebethron garners the autographs of men over five-feet-two who have never burst brazenly into the bed chamber of triplet spinsters (one of whom is away from home visiting an old college chum in Ontario) and awakened the other two by fiendishly shouting the enigmatical expression, "I've mislaid the butterfly's hatchet, which for the purpose of avoiding confusion we shall henceforth term 'Z'!"

An Egg Collection That Is Really Unique!

Mr. Noval Buckbone, and daughter Eeenie, are not collectors of just plain eggs. The Buckbones collect only those eggs that were laid on or near a rowing machine. Eggs that fail to pass muster in this essential the Buckbones refuse to garner (note their garnering rods).

Outlouvres the Louvre!

Unlike the Louvre, which collects anything in the way of pictures, Mr. Whitcomb T. Ankle of the Birmingham Ankles is far more selective in his choice of subjects. Ankle has the largest collection in the world of pictures of things that would be of absolutely no use to a chef who's mislaid the Paprika.

The Latest Developments in Vocal Education

Youth Sings Chord!

A vocal phenomenon, long thought impossible, occurred last week when C. Aschenbach, a Swiss of twelve, sang a full-fledged chord. The rare circumstances that combined to cause this may not repeat themselves again in a million years. It all happened when Aschenbach, a stutterer who lisps and whose voice is changing, was stricken with hiccoughs during his yodeling lesson.

Reading Music at Sight

A sight-reading work-out, now popular in Hungary, is the "Kriemnz Method," illustrated above. An ape wearing black gloves is allowed to clamber on the bars of a hanging "staff." Each child follows a glove and sings the notes as fast as indicated. (A lively ape can create 34,000,000 new tone combinations in the space of an hour.)

The Scale Reform Movement

"For years without realizing it," claims N. Trayfoot, the reformer, "vocal teachers have been putting *indecent words* into our children's mouths in teaching them the scale!" *SOL* and *TI*, he has discovered, both mean something simply awful in ancient Persian! In his crusade for revision, Trayfoot suggests substituting the harmless words, "Hedwig" and "Frith."

Static in its More Subtle Forms

Contrary to Popular Belief, all Static
is Not Caused by Frigidaires
and Passing Streetcars

Every Rudy Vallee fan certainly remembers the earsplitting roar that interrupted him in mid-croon and drowned the syllable "eet" out of "Sweetheart" on Jan. 21st at 9:47 p.m. The disturbance, investigation shows, was an ether vibration caused by a bewildered nightingale flying through an intricate formation in the Cat's Cradle Makers Club in Joplin, Mo. (Vallee is now seeking an injunction to force this club to buy screens.)

Perplexed for months, the Higgsie Andiron Co, has finally located the origin of the static that has been ruining their weekly radio hour. A rival andiron concern, it seems, had discovered that hellish static could be caused by arranging a triangle with a goldfish at one corner, a couple of Trichinopoly cigars at another, and a busby at the apex.

People living near zoos always complain of noisy radio reception. Seeking the cause, Caleb Knud, curator of the Bronx kangaroos, noticed that mother kangaroos and their offspring always breathed in unison. "The draughts," mused Knud, "must cause the static." Breathing experts were called in, and Knud now has the mothers breathing in while the young ones breathe out. The ether about his park is now staticless.

The Perplexing Problem of Household Terminology

Three Great Scientists Who are Seeking to Shed Light on these Matters

How Warm is Luke?

For centuries people have used the term "luke" so carelessly, that its exact meaning has become confused. Many a man has been chilled or scalded to death in a tub his butler believed "luke warm." To end this, the Josiah Windlestiff Foundation had two scientists working day and night, seeking to establish a definition of lukedom that will be universal, once and for all.

To End Odd Use of "Odds and Ends"

"Anyone who says his attic is full of Odds and Ends," says Dr. Ondutt Carbie, who is an authority on such matters, "is making a fool of himself. In my personal investigation of over 5,000 attics this season, I have found Odds galore and Ends galore....but never the two together! To keep people from making this stupid blunder, Carbie is preparing a volume that will explain their subtle difference in detail.

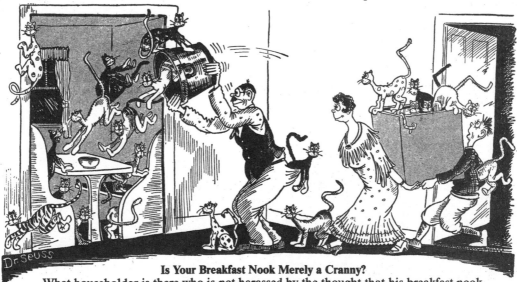

Is Your Breakfast Nook Merely a Cranny?

What householder is there who is not harassed by the thought that his breakfast nook really might not be a nook at all? "Stop worrying! Find out for yourself!" advises Kolph, the deviser of the reliable "cat-test". "If you can get three hundred cats into it, you have a fullfledged breakfast nook. If not, you have only a breakfast cranny."

Somnambulists (and Some Don't)
A Few Notes of Interest to the Sleep-walker

The Wrong Way

The Right Way

The *Haute Mode* in Sleep-Walking Costumes
Sleep-walking at smart Westchester house parties is no longer a *faux pas.* But sleep-walking before the elite in informal pajamas is never tolerated. The Social Register insists on Full Dress pajamas with tails.

How "Frogs" Came to be Worn on Pajamas
This story harkens back to ancient Lombardy, during the reign of Bolivar IX. Bolivar IX was a chronic sleep-walker, and every night he would wander forth, never waking until he had fallen into the river. Annoyed by this, his majesty finally conceived the idea of going to bed with two live frogs tied onto his pajamas. Thereafter, whenever he approached the river's edge, his two frogs commenced croaking to their friends in the water. This woke the king and saved him the plunge. Ever since then, pajama frogs have been all the rage.

Enjoy Companionship While You Sleep!
Why walk in your sleep *alone* when you can get a friendly pet to accompany you on your hikes? The Grimalkin Ostrich Agency furnishes gentle and reliable sleep-walking ostriches at eighty-five cents an hour.

Three More Burning Problems Solved!
Timely Suggestions That Will Diminish the Perplexities of Everyday Life

The Problem of the Bulging Shirt-Front
How can we utilize the wasted space beneath the bulge of our full-dress shirts? Too short to house a dachshund and too narrow for a bowl of goldfish, there is, however, one use to which it is perfectly suited. It will take three canaries nicely. Their heads, moreover, make excellent musical studs.

The Germ Menace, and the Straphanger
The man who is antiseptic-minded will shun the germ-laden straps of the subway cars as poison! It is advisable to stay out of the cars entirely until your beard has reached the length of a serviceable substitute.

How to Eject a Cow From Your Apartment
One of the greatest problems that confronts us New Yorkers is how to get rid of the livestock that follows us home. Once within our comfortable quarters, neither physical force nor the use of harsh words will persuade them to leave. The old "moon gag" of the Mother Goose rhymes, however, will usually turn the trick. Manoeuvre your cardboard moon so that when the cow jumps over it she will unwittingly crash through the window. The giddy drop to the ground will sour her milk and, enraged, she will never return.

Some Common-Sense Safety-First Devices

Safeguarding Our Tailors

Statistics show that every year over 3,000 tailors are rushed to the hospital, suffering acutely from swallowed pins. Consequently the American Tailors' Ass'n has ordered all suit fitters to equip themselves with trained Burmese bissarts. Five pins in the mouth are safe enough; but put in a sixth, and your bissart leans over and snatches it out.

Protecting Our Organists

Though few realize it, organ playing is extremely dangerous. In stamping around on the pedals the organist's shoes are forever untying, and, tripping on the laces, he often breaks a leg. Wise organists, therefore, now have "Ocelot Releases" among the gadgets on their dashboards. When laces get in a snarl, out pops the ocelot to gnaw them loose.

Lessening the Hazards of Shoot-the-Chutes Inspecting

A little-appreciated profession is that of Slippery-Slide Inspector on our playgrounds. These men, who protect our kiddies by testing their slides, get little thanks, poor pay and lots of splinters in the seats of their pants. To combat the splinter menace, progressive cities now allow them to be preceded down the slide by Sumatran honey bears. (Sumatra being full of splinters, the bears pick them up and don't mind it a bit.)

Three New Uses for Obselete Objects

Salvage Antiques from your Attic, and Realize a Profit!

A Use for your Old Brass Horn

Off-hand I can name more than twenty New York bank presidents who would like to eat lollipops on their way to work. But none of them dare; they are afraid that people will talk. If they went to work disguised as bass drum players, however, the size of the horn would divert the public's gaze from the lollipop.

A Use for Broken Barometers

If you run across an old barometer while housecleaning, don't throw it away! Your neighborhood speakeasy will be glad to buy it. All the underworld cafes are hanging them up. . . with the arrows indicating fair weather. When the intruding police see that it is fair weather, they naturally assume that good fellows are getting together. And as they only pinch joints that cater to *bad* fellows, they call off the raid, leaving the place unmolested.

A Use for Your Old Grindstones

Only a few weeks ago everyone was painting Easter eggs. Now that Easter is past, the problem arises how to get the paint off again. People pay well to get their Easter eggs cleaned! The diagram shows two energetic young boys picking up some easy change in their spare time after school.

Adam's Apples Are Coming Back

**Stylish and Smart, They Are Also Important to the
Social and Economic Life of the Community**

The Adam's Apple as a Bridge Signaler

A simple system for telling your partner what to lead! These signals are easily mastered. The Spades signal (in which the Adam's Apple completely circumnavigates the neck) is the only one that presents any difficulty at all.

Are You Flat-Throated?

Do women spurn you because of your neck? Don't despair! You, too, can have a beautiful Adam's Apple! The "Little Nemo" Artificial Adam's Apple costs only a dollar, and cannot be told from the genuine thing.

Can Adam's Apple Energy Be Harnessed?

In less than a million years, scientists tell us, our coal and wood resources will be exhausted. How then will our steamboats and railroads be operated? What then will keep the wheels of industry in motion? "The answer is in the up-and-down action of the Adam's Apple," says Joachim Mueller, German physicist. As a proof of its potentiality, Herr Mueller is shown operating the family ice-cream freezer by Adam's Apple power.

Medicine, Highly Developed in the Day of Pnolioch, Still a Growing Science!
Some Notes of Interest to All Lovers of the Stethoscope

Noteworthy among new medical sensations is Dr. Echo Muff's Whooping Cough Theory, which claims that the germ originates with the adder and is passed on to your neighborhood ostrich. Then comes the obvious stages: Cherries, gnat, the bust in your attic, naval attache, pop-corn popper and your own dear innocent babe. Dr. Muff's idea is to destroy this deadly sequence by tin-plating the bust so the gnat cannot sting it.

In New York, where chaps are forever falling off high buildings, it has become necessary to have Fall Doctors who specialize according to stories. The doctor above, for example, being an expert in mere forty-two story falls, is not qualified to take the case of the poor fellow who has plunged down forty-three.

The dullest feature of a doctor's practice is having to listen day in and day out to a lot of stupid children saying, "A-h-h-h-h!" The Committee for the Abolition of A-h-h-h-h is therefore offering a prize of $5,000.00 to the child who can invent the most euphonious substitute. The committee is shown above, giving an audition to a number of contestants.

Our Lamentable Misuse of Certain Fine Old Terms—

Striking Examples of How Phrases Have Strayed
From Their Proper Meanings
By Dr. Theophrastus Seuss

The Deplorable Misuse of "Frazzle"

Even Gene Tunney, with all his precision of speech, once made this blunder. In describing his fight with Dempsey, Gene recently told me, "I wore that guy to a frazzle!" How he opened his eyes when I informed him that a "frazzle" is an informal evening's entertainment peculiar to Kansas—a combination smoker, drinker and chewer that usually ends in a crap game! In the picture above a man is shown wearing another man to a frazzle. (Correctly speaking, Tunney wore Dempsey to no such thing.)

Our Ridiculous Misuse of "Agog"

How well I remember the day Lindbergh landed in Paris. A day of glory for America, to be sure . . . but, at the same time, a day of lowly shame! For thousands upon thousands of our citizens stupidly gurgled, "I'm all agog!" How pitifully stupid! There's not a Gog in America. Little did they know that a Gog is a sentimental Swiss who collects mountain-goat tears in a brown paper bag. Unless you are one of these, you should never use the term.

Our Ignorant Misuse of "Befuddled"

If anything makes me writhe with indignation, it is to hear the remark, "I'm so befuddled!" At one time my own grandfather was famous as the world's champion heavyweight "fuddler." To misuse this term is to insult his memory.

"Fuddling" was to the gay nineties what "beaver" is to us today. The purpose of the game was to pop suddenly out of the bushes and slap a fop smartly across the nose with your "fuddle" (a durable kind of baloney). The fop whose nose was slapped was considered "befuddled." Anyone claiming "befuddlement" today is talking through his hat.

"Left in the Lurch" and Just What Does It Mean?

Wherever You Roam, You'll Always Find Lurches Are Different

The Lurch in the West

"A lurch," says Simon Whistlebooster, the famous traveler, "is a *de luxe* accommodation aboard a speedy transcontinental lawn mower. In passing over the foothills of Nebraska, it often happens that the engineers desert their posts and go native. The passenger, then, is left in the lurch."

The Lurch in the South

"A lurch," Writes Annabelle Choochoocubb of Lexington, Ky., "is a sag in the back of a lady's gown. In the old days, at tiddle-de-winks tournaments, the winks were forever going astray and popping into some damsel's lurch. And as all men were gentlemen in that era, nothing was done about it. The tiddle-de-winks were left in the lurch."

The Lurch in the East

"There's only one true lurch in the whole country," declare the Frothingham Bros., "and that's our lurch in Cambridge, Mass. Here the Harvard boys get their croquet wickets straightened out before sending them home at the end of the year." (The picture shows a sophomore, leaving the Bros. in the lurch.)

Recent Developments in the Field of Clothing

The Super Lapel

Sleeve-Button Problem Solved!

Last week the city fathers of Thnoddy, Mich., found an inspired answer to the old question, "What good anyway are the buttons they put on our coat sleeves?" "Buttons," they reasoned, "call for button holes." Today you will find button holes in every lamp post in Thnoddy—just the thing to button your playmates to when they prove too difficult to steer home.

Out in Toledo a tailor named Whelk has developed a new wrinkle that will take most of the worry and expense out of love-making. "How," asks Whelk, "can a chap surrender to ecstasy when he sees his fifty-cent gardenia being rumpled and crushed?" Whelk's Super Lapel saves wear and tear on your gardenia by putting it into a neutral zone high above the friction area.

Tense Situation at Lindenmayer Foundation

Students of the History of Clothing are focusing their attention today on the lecture hall of the Lindenmayer Foundation for Sartorial Research. For here two factions are hotly debating the most momentous problem the society has ever tackled. When the final vote is taken, an eager world will know, once and for all, the answer to that mooted question, "Just what did Adam wear...suspenders or a belt?"

Just What Is A Vernacular, Anyway?

A few of the answers to the nation-wide questionaire sent out by this department to ascertain exactly what is meant by the phrase "They were talking in the vernacular."

"You are quite wrong," writes a prominent radio tube testeress, "in assuming that two men can talk in one Vernacular. Around these parts a Vernacular is a sort of a yachting hat worn by the drivers of aerial dog sleds. As only one man can wear one hat at one time, the phrase should be corrected to read,'They talked in two Vernaculars!'"

"Whatever a Vernacular is," writes one correspondent, "there is one thing I am positive it is not. A Vernacular is certainly not a shoe-shining stand, the footrests of which tower to the unbelievable height of ten feet six and one-half inches. Only yesterday I was in one of those things and was too flabbergasted to say a word, and if a fellow can't speak in a thing, then the thing surely cannot be a Vernacular.

"Personally," writes Enobarbus Bellamy 3rd of Snas, Conn.,"I have never seen a Vernacular, but I distinctly recollect hearing grandmummy relate how grandpuppy frequented them back in '76. A Vernacular, as she told it, was any two-passenger cave through the roof of which radish roots protruded. They were all padlocked in '79, however, due to the death of many habitues from radish root tickle."

An adroit solution that is probably as near to the truth as any is forwarded by a Mr. Smallgnome of Left Antler, Vt. Mr. Smallgnome proffers the information that in his vicinity a Vernacular is nothing more than a wire net sort of a thing, large enough to enclose the heads of two drum players, but not quite three.

Monosyllabic Ejaculations

And What To Do About Them

The Perversion of "Ugh!"

To me, our wanton misuse of the ejaculation "Ugh!" is most distressing. Only yesterday I was profoundly shocked to hear it from the lips of a seemingly intelligent steeplejack's wife as she watched her husband fall off his steeple. I consider that inexcusable. Properly used, "Ugh" should only be ejaculated by little girls of seven to express their contempt for brewery wagons. The more I think of that steeplejack's wife, the madder I get.

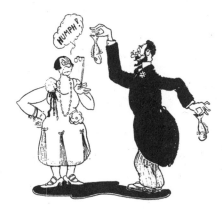

Coaching a Deb

"A debutante's success," says Prof. Schnittknecht, the Grammarian, "depends largely upon her proper use of words—especally those sticklers, *humph!* and *faugh!* If a boorish chap brings a dead fish to your coming-out party, you should always meet the situation with *'humph!'* This signifies mild contempt and semi-unconcern. But if a boorish chap brings *two* dead fish, you must actually be haughty. 'Faugh!' is the term for two dead fish. Keep those words straight in your pretty little head, and you will go a long way socially."

A Costly Grammatical Error

The worst blunder I ever made was in Buckingham Palace, where for three months I had passed myself off as the Prince of Wales. I had fooled the King, but the Queen was a wee mite suspicious, so one afternoon she had me beaned with a pot of geraniums. "OOP!" I ejaculated, and the cat was out of the bag! (If you examine the accompanying chart, you will see that "OOP" is only used when a gentleman is beaned with a Listerine phial.) Exposed by my ignorance of the King's English, I was exiled, and the true Prince of Wales, whom I had hidden, was returned to his rightful estate.

A Brief Resume of the Eyebrow Situation
An Anatomical Discussion
By Dr. Theophrastus Seuss

The Knitting of the Brow

One of the greatest anatomical fallacies of the day is the supposition that a man can knit his own brow. Many try, but they drop so many stitches that the result is a pitiful failure. It is far better to go to some expert old knitter whose years of practice have made her deft with the needles.

Clearing Up a Misunderstanding

Many people believe that the terms "high-brow" and "low-brow" actually have something to do with the human forehead. This is erroneous. What they really refer to is a man's capacity as a brau drinker. In Germany, the gentleman who can down a *high brau* is accepted as an aristocrat. If you can only absorb a *low brau,* you are considered a member of an inferior social stratum.

How We Have Garbled as Ancient Practice

In prehistoric days, when a wife displeased her husband, he punished her by stringing beads on her eyebrows. (At that time, feminine eyebrows attained the length of eight or ten inches!) This custom was known as *brow-beading.* With the passage of centuries, however, their eyebrows shrunk and the custom disappeared, In reviving the practice, we have wrongly assumed that "beading" was a misspelled form of "beating." And that is why we *Brow-beat* our spouses today.

Three Fine Social Arts We Are Prone to Neglect

The Fine Art of Sneezing

"The social education of our youth," says Dr. Farquarharson Fohsnip, "is too one-sided. Although well-schooled in manners generally, not one child in a hundred can sneeze with grace. To revive the art of beautiful sneezing, Dr. Fohsnip conducts tutorials, teaching his pupils from phonograph records of the foremost maestros of sneezery.

The Fine Art of Hiccoughing

A sudden attack of hiccoughs at a tea party has been many a poor fellow's social undoing. But spilling tea down your hostess' guimpe can be avoided if you prepare yourself with the Lehrenkrauss Hiccough Machine. After practising the hiccough contortions for a month or two, you can handle the teacup without spilling a drop.

The Fine Art of Yawning

"It is always correct to yawn when bored," says Prof. Zeno Chilk of the Chilk School of Yawning. "But to yawn the same way at everyone is decidedly gauche. There are over three thousand different kinds of yawns, each depending on the social station of the yawnee." Prof. Chilk is shown instructing a pupil in the first five.

Tardy Laurels for Forgotten Brows

The Original "Ups-A-Daisy" Baby

Everyone knows how the jolly pastime of "Ups-a-Daisy" was invented... how Tim O'Hara bounced a tot on his knee while Jim O'Hara looked up names of flowers...How, after bouncing him 34,798 times, they found that Daisy was the flower he most enjoyed being bounced to. The O'Haras are famous—but only now have we learned the baby's name. Next Thursday will be observed as Tommy Phipps Day throughout the nurseries of the land!

The Jack Robinson Fraud

Credit for inventing that fine old phrase, "Quicker than you can say Jack Robinson," has always gone to Jack Robinson of London. Last June, however, Robinson admitted he had stolen the idea from an Eskimo—the original wording being "Quicker than you can say Iiijiwik Iiiijiblong." To make amends, a special Arctic expedition has just ferreted out Mr. Iiiijiblong and bestowed on him the world's appreciation.

The Inventor of Up-Your-Sleeve-Laughing

How many of us, while enjoying the sport of laughing up our sleeve, ever give a thought to Tinchcape Gillingsworthy, the man who made it possible? Before Gillingsworthy invented sleeve-laughing, hundreds of necks were broken annually by people trying to laugh down their shoe backs or into the cuffs of their pants. The new Gillingsworthy memorial at Canajoharie shows graphically just how much we owe to this emancipator's genius.

Tardy Laurels
(Cont'd)

A Pioneer in Child-Upbringing

Spelling out words so your child won't catch on is now a universal strategy. But only after twenty years of usage has its origin been traced to its inventrix... Mrs. Uggdugg, of West Icicle, Greenland. Mrs. U. well deserves our plaudits for her originality... but twice as many plaudits for her bravery. The mere fact she dared spell "candy" in Eskimo marks her as a fearless pioneer.

Voluntary Martyrs to Spot-Marking

When one assumes that "X" has always marked the spots where bodies are found, he is doing grave injustice to the three Twidd brothers, late of London. Prior to their time spots were marked with any old letter that happened into the spot-marker's head. Crusaders for unification, the three brothers pre-marked their own spots "X" and destroyed themselves. "X" has since been adopted as a tribute to their sincerity.

Unsung Enrichers of the Tongue

One never knows how much work it is to coin a simple expression. Take, for instance, the difficulties met by the Coining Academy in coining *"As much privacy as a fish in a fish bowl."* For months they were undecided whether to make it *"As much privacy as a bird in a bird cage."* Only through great personal sacrifice on the part of two members did the academy secure the first-hand data necessary to making their choice.

Tardy Laurels
(Cont'd)

The Jacques Brioche Memorial Medal
Just 467 years ago J. Brioche, French savant, took a group of six onions and compared it to another group containing half a dozen onions. To his amazement he discovered that each group contained the same number of onions. This audacious experiment gave us that foolproof expression, "It's six of one and half a dozen of the other." Unacclaimed for centuries, Brioche has at last been immortalized in bronze by the metal-working class of the Junior High School in Brisket, Minn.

A Statue to Bung
When Winfield invented the bathtub in 1460, he made one serious omission. He invented a drain, but forgot to invent the bung. Consequently the water always ran out and made you mad. Readily sensing what was wrong, Sir Joshua Bung devised the ingenious stopple that bears his name. Commemorating his inspiration, a lovely statue has just been unveiled in Kraut Park, near Secondtooth, Ark.

The Great Zakkx Pageant
Anyone can invent something complicated, but the real inventor is one who invents something simple. Ages ago, for instance, people stood up all the time...simply because no one had yet invented sitting down. Then came Xax Zakkx. A man of wisdom, Zakkx sat down, and ever since we have enjoyed the fruits of his genius. Last week Zakkx was extended a long belated ovation by a pageant in his honor in South Herb, Mont.

Tardy Laurels
(Cont'd)

The Originator of the Ditto

From Munich comes the news that the Inventor of the Ditto has at last been discovered. He is Herr Gustav Ditt, and the original ditto marks still appear on his upper lip whenever he smiles. Too lazy to beckon waiters by hand, Ditt signals them with a broad grin that separates his moustache in twain. As he has been drinking since '97, two black jots are now universally symbolic for, "One more just like the last!"

B-P-Hot Wizard at Last Revealed!

The old theory that the game of Beans-Porridge-Hot was invented by Alaskan Indians was conclusively quashed last month by the Thinsen-Hurlidigh Expedition for Conclusively Quashing the Theory that B-P-Hot was Invented by Alaskan Indians. In the far Klondike they found "Lone Tod" Welch, who for forty years has amused himself with a B-P-Hot playing machine of his own devising. And all this while the plagiaristic Indians have nabbed the credit!

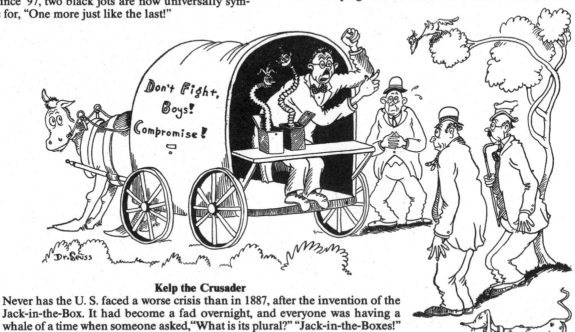

Kelp the Crusader

Never has the U. S. faced a worse crisis than in 1887, after the invention of the Jack-in-the-Box. It had become a fad overnight, and everyone was having a whale of a time when someone asked, "What is its plural?" "Jack-in-the-Boxes!" claimed some. Others hotly insisted, "Jacks-in-the-Box!" Civil war seemed inevitable, when Zeke Kelp's Crusade won a compromise on, "Jacks-in-the-Boxes." Unthanked for forty-three years, Kelp will be honored next week when N. Y. City unveils a hydrant in his name.

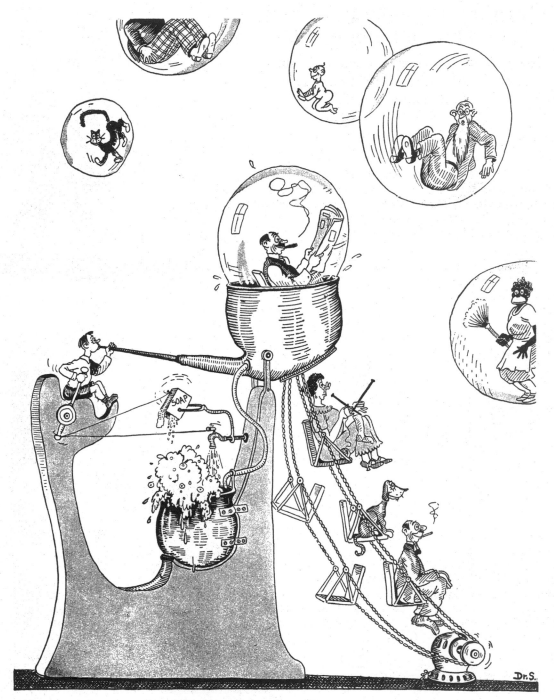

How soap-bubble blowing may be made a truly fascinating pastime.

Our Emotional Apparati and How They are Controlled

The Ardour, the Gumption and the Dander all demand as much attention as the Teeth and the Nails

By Dr. Theophrastus Seuss

The Care of the Gumption

One part of the human equipment that should never be slighted is the Gumption. To cure one of chronic laziness and sloth, stir the Gumption vigorously on the first Tuesday following the first Monday of every month.

Where Is the Dander, and How To Get It Up?

There are two divergent schools of thought concerning the Dander, each claiming that it is situated in a different locality. Hence, when you want to get your Dander Up, you must employ two doubtful methods alternately. (note—The same confusion exists in regards to the Ire, which may be raised in the same fashion.)

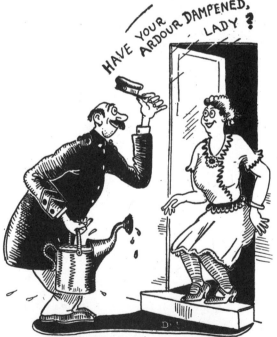

The World Now Ardour-Conscious

A few years ago, no lady could mention her Ardour without a blush. Today, happily, people are more frank. They have their Ardours dampened regularly by experts, and dicuss the treatment afterwards without the least embarrassment.

The Pitfalls That Beset
Our Infant Prodigies

A Whole Career Wrecked by Luck

The most difficult sonata ever written is Mozart's "B Duet for Kettle-drum and Thrush." Even if the drummer is a genius, the thrush, who warbles the accompaniment, can spoil everything. Prodigy Georgie Flueh found this out during his debut last week at Carnegie Hall when the thrush carelessly laid an egg in the drum. This made one boom too many, and poor Georgie was hissed into oblivion.

The Hazards of Comb Playing

Two years ago, the melodies of Thrubber Z. Nalgon were enchanting the concert world from Newton Center to Johore. Never had anyone heard sweeter tones than those this gifted stripling produced on his Comb-and-Tissue-Paper. But Nalgon was forced to retire when stricken with that scourge of all players of the comb —hair lip.

The Prodigy as a Smart Alek

The thing that ruins more prodigies than anything else is their love to show off. Young Prescot Jivler, the French Horn Wizard, for example, recently equipped his tricycle with a thirty-foot horn in place of the usual bell. Last week, when Jivler misjudged the height of the Holland Tunnel, his career was brought to a tragic conclusion.

89

Why I Turned Democrat
Four Noisome Republican Abuses That Occasioned My Conversion

A Democratic President Means a New *Put-Your-Finger-Here Man!*

Each Christmas the War Department spends two million dollars in surprising every soldier in Alaska with a pair of mohair ear-muffs. A cousin of mine, who is in the ear-muff game himself, places the actual cost of the muffs at only ONE million dollars. How, then, Mr. Taxpayer, is your other annual million swallowed up? Simply through the inefficiency of the two men who do the wrapping—the *String Man* and the *Put-Your-Finger-Here Man*.

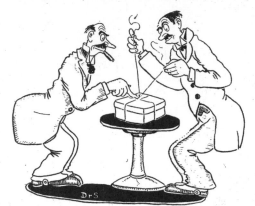

The latter gets his finger there all right, but he is so slow when it comes to pulling it away that it usually gets tied onto the bundle. The extra time involved in getting his digit out accounts for the wasted million. Al Smith would give this job to a couple of experts, the *String Man* and the *Put-Your-Finger-Here Man* who worked with him in that fish market down on the old East Side.

Farm Relief Flatly Refused by the Republicans

Although I live on the fifteenth floor of a Bronx apartment, I am a dairy farmer in a small way, keeping my cow, Cadwaller, out on the back veranda. In recent months Cadwaller's milk output has fallen off steadily. At first I blamed this in the new next-door skyscraper which is shutting out the sunlight, but last week I discovered the true reason. Every morn at dawn the man across the alley leans over and milks Cadwaller dry! Thrice I have begged the Department of Agriculture to intervene, but my letters remain unanswered. In the meantime the thievery goes on, and will go on, I suppose, until the day that Al moves into the White House.

Aerial Outlawry

With all their talk about law and order, what have the Republicans done toward cleaning up Vice in the Air??? The illustration depicts just one of its many grim aspects—aerial sneak-thievery. Unhampered by the police, the winged felon is successfully picking an air pocket.

A Republican Plot Against Personal Liberty

In 1918 Herbert Hoover went abroad to feed the Belgians. When the banquet was over and the cigars were being lighted, Mr. Hoover made known his Philosophy of Tobacco. "If I am ever president," he is said to have said, "I propose to abolish all individual smoking in America. I do not mind smoking in itself, but at the same time I don't want to see the boys playing with matches." Mr. Hoover's plan would have all *private pipes* destroyed, and in their place would erect one *central pipe* in Washington. Each state would receive its quota of smoke through one of the forty-eight stems, each city would maintain a sub-branch off the main line, and each family would have a nozzle in its parlor, payment being made in accordance with the monthly meter reading. Democrats, to arms! Shall we allow a Secretary of Tobacco to choose and dictate the brand we are to smoke??????

Boids and Beasties:
Piscozooavistical Surveys

How Animals Served Us Before the Advent of Science.

Certain Fine Old Beasts Who Have Been Driven To Extinction by Modern Methods.

The greatest handicap historians experienced during the Middle Ages was that the Blotter had not yet been invented, and their writing was forever getting smeared. Hugo of Bezzelschnep was the first to get around this. He introduced the Absorbent-Pawed Dingo—a tireless pup whose circle-walking habit brought him back on the paper every time Hugo finished a line.

Notable among the victims of the ruthless march of science is the now extinct Nelp, or Welsh Chamois. For centuries herds of Nelp were raised for their slender horn, which cooks employed to stab into cakes to see when they were done. Then came August, 1427, and the Invention of the Broom! By furnishing our cooks broom-straws instead, we now save thousands of dollars yearly . . . but the Nelp is gone, and our forests are the poorer for his passing.

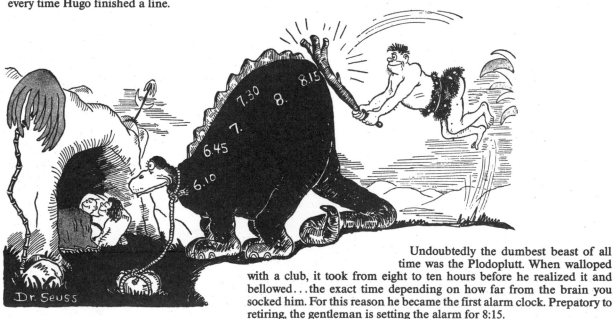

Dr. Seuss

Undoubtedly the dumbest beast of all time was the Plodoplutt. When walloped with a club, it took from eight to ten hours before he realized it and bellowed . . . the exact time depending on how far from the brain you socked him. For this reason he became the first alarm clock. Prepatory to retiring, the gentleman is setting the alarm for 8:15.

Fish Racing Growing as Fad

"May Supplant Baseball." says Judge Landis
(who is reputed to have bought him a halibut).

Making a Liability an Asset

When J. Whelp Grimalkin, the Sporting Millionaire of Los Angeles, died last spring, he left every penny to charity. To his estranged son, Jack, he sarcastically bequeathed his kennel of Flying-Fish. Never having won a single race, these fish were the laughing stock of sporting circles. "Take 'em and eat 'em," read the will.

The penniless youth considered the proposition with care. True, there were enough fish to feed him the rest of his life, but as his father had bequeathed no caper sauce to go with them, Jack chose the only other alternative. *He would train these doubtful fish to race and win!* A consultation of scientists informed him that their sluggishness was due to over-exposure to the sun when they flew. So Jack promptly had each fish fitted out with an awning! Thus sheltered from the garish heat, the flying fish regained their strength. Their recent winnings have made Jack twice as rich as his old man.

The Psychology of Victory

Like race-horses, racing fish must be humored if you want them to win. D'Artagnan d'Murphy, owner of the fleetest pair of racing mackerel in all the world, keeps them in spirits with daily concert programs. The mackerels' favorites are virtuoso Peppinni, the submarine hurdy-gurdist, and his submarine monkey, Babs.

Advice to Wager Makers

The first thing to do before betting on a pair of fish is to ascertain beyond a doubt that they are both of the same sex. Last year the Newport Tandem Championship was won by fish-jockey Zeke Zwirz, who came in first on two male herring. Although the opposing team was really the favorite, Zwirz took advantage of the fact that they were male and female and just before the race he stealthily fed them a love potion. Halfway down the course they took to making eyes at one another. Whilst they were thus dallying, Mr. Zwirz sneaked over for a victory.

Hats Off to the Eels

It is with regret that we learn that hereafter all eels will be barred from competing in the International Fish Derby. This new ruling is simply a matter of sour grapes. All eel fanciers and eelophiles know that these slippery fellows are so fast that the other fish are ashamed to race against them. The illustration pictures a couple of them showing their opponents a clean pair of 'eels.

How Certain Fine Dumb Creatures
Have Fostered
the
Noble Cause of Justice

That bovines also have ethics is proved by the current story of a cow who knew that a certain Chicago house was a Speakeasy. Eager to inform the police, the dumb but canny beast patiently parked in front of the place . . . and concentrated. By the end of a fortnight, her horns had grown into the shape of a pretzel. Ever alert, the police understood. The beer joint was padlocked.

At last, after seventeen years, the true story of "Spider" Connor's capture can be told. After shooting d'Button, the turfman, that night in 1912, it seems that Connor paused to toss his victim's goldfish a morsel of fish food on the way out. Realizing that the fish food bore a tell tale fingerprint, the fish caught it and patiently kept it above water until the police noticed it some three months later.

Now that he has passed on and the Spider's pals cannot take him for a ride, there is no need to suppress his story any longer.

Dr. Seuss

When an Eskimo's wife elopes with another man, the husband immediately makes snow men resembling all the chaps that he suspects. Then, sitting the family penguin on a morris chair, he points them out one by one. The nervous penguin invariably betrays the guilty party by an involuntary flutter of the eyelids.

This is the origin of our own term for a bird who informs, only for penguins we have substituted pigeons and for morris chairs, ordinary stools.

Make Christmas More Meaningful

And Save 35,000,000 Hours Yearly!!

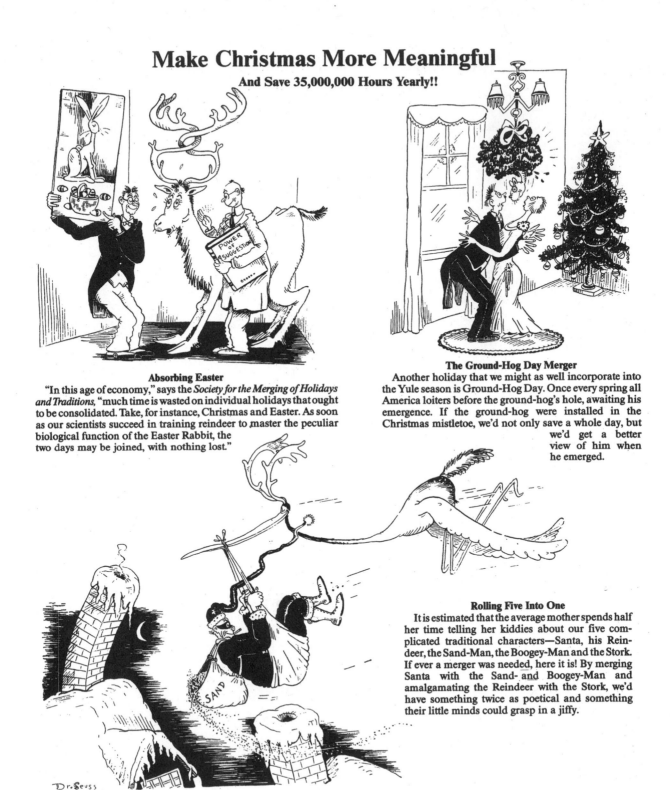

Absorbing Easter

"In this age of economy," says the *Society for the Merging of Holidays and Traditions,* "much time is wasted on individual holidays that ought to be consolidated. Take, for instance, Christmas and Easter. As soon as our scientists succeed in training reindeer to master the peculiar biological function of the Easter Rabbit, the two days may be joined, with nothing lost."

The Ground-Hog Day Merger

Another holiday that we might as well incorporate into the Yule season is Ground-Hog Day. Once every spring all America loiters before the ground-hog's hole, awaiting his emergence. If the ground-hog were installed in the Christmas mistletoe, we'd not only save a whole day, but we'd get a better view of him when he emerged.

Rolling Five Into One

It is estimated that the average mother spends half her time telling her kiddies about our five complicated traditional characters—Santa, his Reindeer, the Sand-Man, the Boogey-Man and the Stork. If ever a merger was needed, here it is! By merging Santa with the Sand- and Boogey-Man and amalgamating the Reindeer with the Stork, we'd have something twice as poetical and something their little minds could grasp in a jiffy.

The Beast as Man's Best Parlor Companion.

Glimpses of Communities Where Animals Augment the Richness of Man's Life by Assisting Him in His Games.

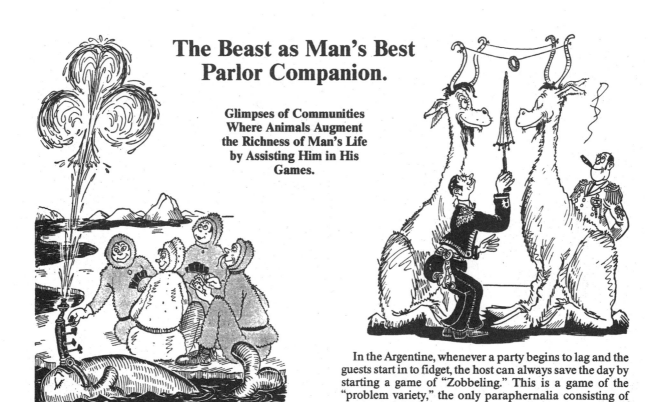

North-east of Iceland in Uewk, the Eskimos never sit down to a bridge game without a whale as a fifth. By affixing an "Iblogg"(or "Spray Controller") onto his spout, they can shape his spray into hearts, clubs, diamonds or spades....an ingenious system to remind them what's trumps. This use of the whale accounts for their expression, "Let's sit down to a blubber of bridge."

In the Argentine, whenever a party begins to lag and the guests start in to fidget, the host can always save the day by starting a game of "Zobbeling." This is a game of the "problem variety," the only paraphernalia consisting of two buck Zobbels, two pieces of string, a sugar doughnut and a parasol. The idea is to get the sugar doughnut onto the other string without removing the Zobbels' horns.

When Gen. Grant was on his world tour in '77, he chanced, as a diplomatic gesture, to introduce the Amir of Iraq to our game, "Going to Jerusalem" or "Musical Chairs." As scrambling for chairs in person struck the leisurely potentate as a trifle too violent, he adopted the game in a more subtle form. With snails scrambling for snail-sized chairs, the Amir's game has now been in progress some 53 years....handing him a good long thrill with practically no commotion at all.

Dr. Seuss

The Lap Dog Situation

The Dangers of the Small Lap

"Last year," declares the "Lap-Dog Lovers' Annual," "over 3,000 Pekinese were injured in falling off laps that were too small." As little-lapped ladies will not give up their dogs, the society hopes to end the danger by other means. It firmly advises the use of Pekinese Props *by all ladies whose laps have an area of less than five square inches.*

Meeting the Theft Problem

Due to economic depression, lap-dog thievery is now on the increase. But in Tulsa the ladies have fooled the felons. "When we own a priceless necklace," they reason, "we lock it in the vault and wear an imitation." Tulsa banks are now specializing in lap-dog storage and the ladies are coddling facsimilies made of muslin.

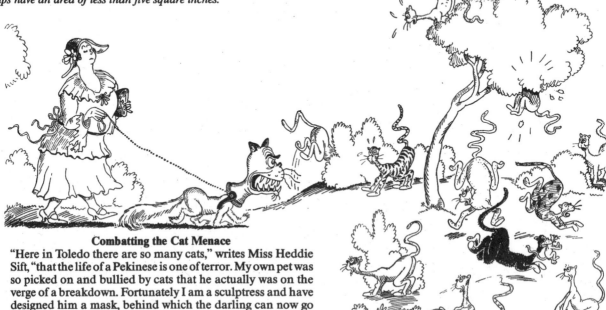

Combatting the Cat Menace

"Here in Toledo there are so many cats," writes Miss Heddie Sift, "that the life of a Pekinese is one of terror. My own pet was so picked on and bullied by cats that he actually was on the verge of a breakdown. Fortunately I am a sculptress and have designed him a mask, behind which the darling can now go practically anywhere unmolested."

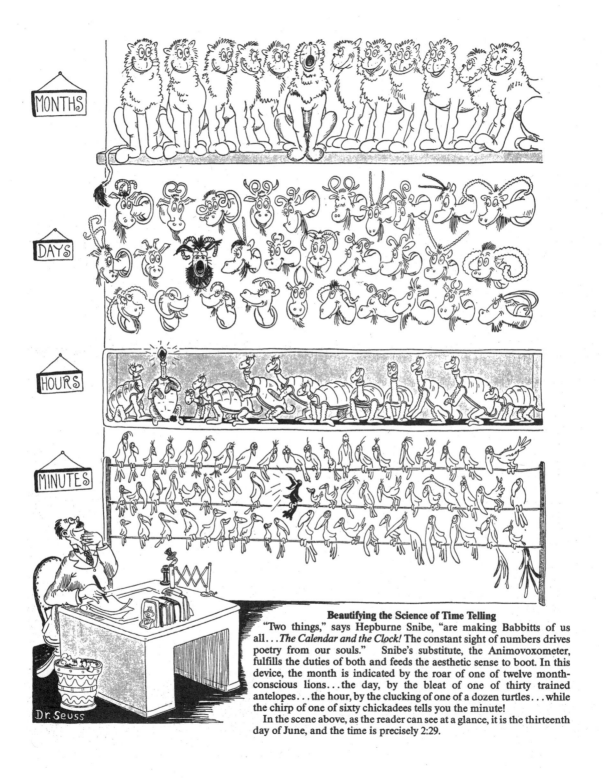

Beautifying the Science of Time Telling

"Two things," says Hepburne Snibe, "are making Babbitts of us all...*The Calendar and the Clock!* The constant sight of numbers drives poetry from our souls." Snibe's substitute, the Animovoxometer, fulfills the duties of both and feeds the aesthetic sense to boot. In this device, the month is indicated by the roar of one of twelve month-conscious lions...the day, by the bleat of one of thirty trained antelopes...the hour, by the clucking of one of a dozen turtles...while the chirp of one of sixty chickadees tells you the minute!

In the scene above, as the reader can see at a glance, it is the thirteenth day of June, and the time is precisely 2:29.

99

Some Recent Developments in Cuckoo Clockery

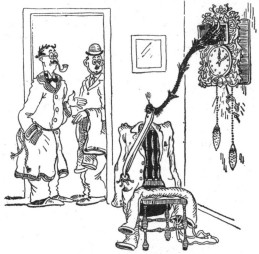

The Pocket Frisking Model

Man's most costly habit is forgetting to look through pockets before sending a suit to the tailor's. Consequently, no one should be without a Pocket-Frisking Cuckoo. The bird above is shown saving his master four valuable keys—one to the house, one to the office, one to the cyclone cellar, and one to the apartment of a Miss Hedwig Thibney.

The Deaf and Dumb Model

In chess clubs, where noise is taboo, cuckoo clock salesmen have always met with defeat. The Weinstien Cuckoo Clock Corp., however, has at last produced a model which will not disturb the finickiest of players. Instead of cuckooing audibly, the bird is a mute and does his stuff in sign language.

Dr. Seuss

The Suitor-Evicting Model

Bnai Bros., Inc, the Boston Bird Breeders, are marketing a clock that is a godsend to the fathers of debutante daughters. Father merely sets the clock for the hour he desires the suitors to depart. When the hour strikes, an avalanche of ferocious cuckoo-vultures swoops out, and in a twinkling the parlor is swainless.

Animals That are Making Our Land a Better Place to Live In

The F.-S. Parakeet
Probably the greatest development in bathtub fixtures since the invention of the bung is the Faucet-Sitting Parakeet. This bird is a godsend if your faucets have been installed backwards—the hot on the right instead of the left. When you instinctively grasp the right handle for your cold morning shower, the parakeet saves you a scalding with a reminding nip on the digits.

The Cholmondelet
Of all American animals, the Cholmondelet has always been considered the most useless. Recently, however, the government decided to utilize his most outstanding characteristic...his Look of Reproach. As a test case, they installed a Cholmondelet at the mail-box on the corner of Thurk Street, Guimp, Idaho. In one year divorces on Thurk Street, Guimp, Idaho, decreased over 14 percent.

The V.-T. Blippard
One of the most laudable societies in the country today is the *Anti-V League,* a group that objects to the use of "V" instead of "U" in spelling Public Library. The league crusades in offending communities by releasing hordes of V-Tagging Blippards—animals trained to tag a "V" whenever they spy one. Only when the library promises to come across with a "U" does the league call off its blippards.

Vacationists! Are You Taking Your Pets Along?

Some Summer Hints to Pet-Possessors

Off for the Holidays

What's a vacation if you leave your pets behind you? With your canary and goldfish languishing with your landlady, your hounds boarding in some forlorn old kennel, your rabbit in a rabbitry, your rattlesnake in a snakery, and your ostrich wandering mournfully about in Uncle Stanley's three-room flat—the whole family seems woefully torn asunder!

Why not take them with you? The Seuss Rumble Seat will solve your vacation's knottiest problem!

You Leaving Your Kittens at Home?

If your cats are too numerous to take along with you, put them away for the summer in moth balls! The proper proportion is one moth ball to five hundred cats.

Packing Your Guinea Pigs

In transporting guinea pigs, the man of foresight will *not* use an ordinary hand bag or grip. The proper thing is an old accordion—allowing as it does for infinite expansion.

The Animal as a Practical Joker

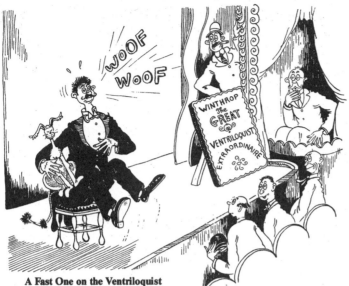

A Fast One on the Ventriloquist

It was the practical joke of a mere airedale that wrecked the career of Winthrop, the famous ventriloquist. Winthrop had treated his "dummy," Piedro, very badly, and seeking revenge, the dog took up ventriloquism on the sly. One night, in the midst of the act, Winthrop found himself barking like a fool. Hissed off the stage, he never landed another contract.

A Fast One on the Bathtub Reader

Probably the greatest practical joker of all time is the Jibbet. The Jibbet dedicates his whole life to one grand jest, and in pulling it he meets his death with a chuckle. His specialty is getting into drain pipes and pushing out the plugs of bathtubs in which someone has just settled down for a quiet half hour with a story.

A Fast One on the Wedding Guests

Out in the woods near Westport there is a rabbit whose sense of humor is really tremendous. It is his gag to get himself pursued by hunters, leading them a merry chase right into church to a wedding. The appearance of an armed individual at a wedding makes the guests believe it is a shotgun affair. This amuses the rabbit no end.

How to Play
Phrugmhumnb la!

A game for the children on rainy afternoons

Basically a simple sport, phrugmhumnb la! can be played by any
two children whose mother can gather thirty cats and persuade them
to hold thermometers in their mouths. This done, each cat is then
cajoled into a different degree of temperature. The point of the game is for the kiddies to guess the sum total of all the
different temperatures. The child whose calculation is the closest is rewarded with a plum duff. The other child gets
only a plain ordinary duff.

104

How to Construct A Cheap But Reliable Gnorfer

(An amphibian Sailing Vehicle for swains who desire to play "She loves me; she loves me not," using giraffe eyelashes instead of the conventional daisy.)

Note: Eight full courses are usually necessary to detain the giraffe for a complete de-eyelashing. (And above all, no parsley-butter on the mackerel!)

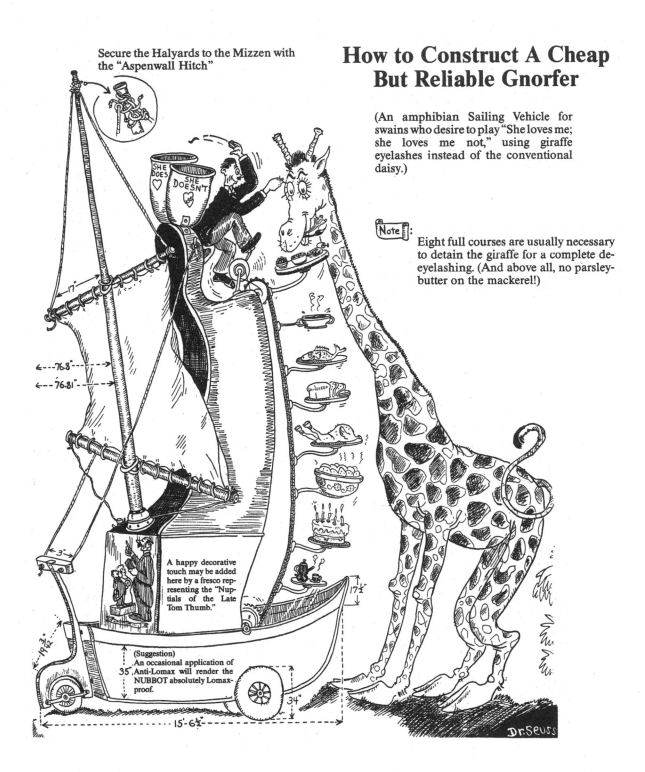

Secure the Halyards to the Mizzen with the "Aspenwall Hitch"

SHE DOES

SHE DOESN'T

A happy decorative touch may be added here by a fresco representing the "Nuptials of the Late Tom Thumb."

(Suggestion) An occasional application of Anti-Lomax will render the NUBBOT absolutely Lomax-proof.

Dr.Seuss

A Foolproof System for Cheating at Solitaire.

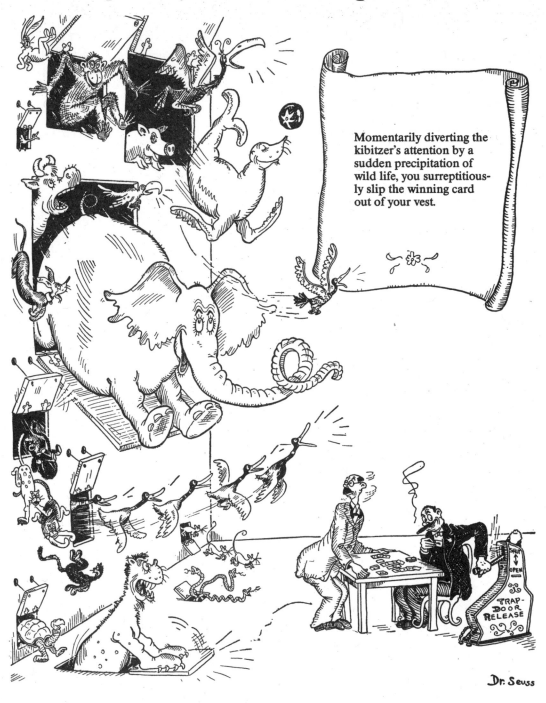

Momentarily diverting the kibitzer's attention by a sudden precipitation of wild life, you surreptitiously slip the winning card out of your vest.

Dr. Seuss

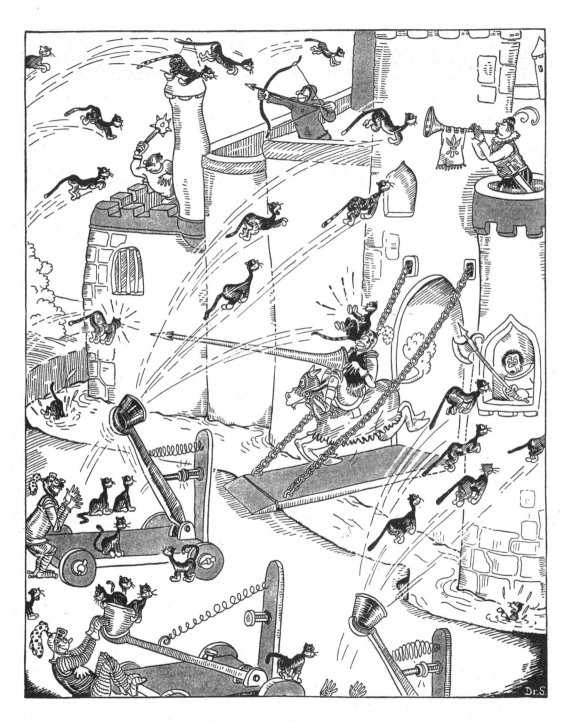

The Mediaeval Art of Catapulting.

Matters of Equestrian Concern

Martyrs to a Great Cause

When Mr. and Mrs. Lee Jamison of Ipswich, Mass., heard the terrible rumors of how badly Mussolini was treating all the Italian horses, did they sit still and do nothing? No! These good people made a personal investigation of the matter. They dressed up in a horses's skin and traveled from one end of Italy to the other as a native beast. In Naples, unfortunately, they were hitched up to a fruit cart and beaten to death by the pedlar because they did not trot fast enough. Dead though they are, may their spirit live on and may their martyrdom insure against further atrocities of this nature!

A Hitherto Unpublished Fact

A friend of mine who is a great student of history recently made the astonishing discovery that Lady Godiva's bareback ride through the streets of Coventry was NOT so romantic as everyone thinks. He learned that for THREE WHOLE DAYS before her public appearance the sly lady practiced riding on her kid brother's hobby horse! And my friend has the hobby horse to prove it.

Can a Horse on Snow-Shoes Beat a Horse on Skis?

For years this has been a moot question among the natives of Hanover, N.H. Determined to end the controversy, last Saturday Fire-Chief Pete Blodgett took his two finest stallions out to a field full of snow and put on a race. But, alas! the race was never finished, for scarcely had it started when some practical joker rang in a false alarm. Blodgett is sore and doesn't give a hoot now whether the question is ever answered or not.

The Origin of an Old Saying

Once upon a time there was a fresh young Knight who spent all his time riding about England on a very tall horse. It was his wont to prod innocent yokels and serfs with the point of his lance and then to jeer at them. For his horse was so tall that they could not reach him to eke out their revenge. All they could do was shake their fists, and dare him to "come down off his high horse." And that's where the wise crack originated.

The Truly Dumb Animal Shoppe

For dumb but proud people who wouldn't keep a pet more intelligent than themselves.

Dr. Seuss's
Cartoon
Collection

"Hey, Mama! Kitty's come back!"

"If we could find a fourth, we could at least play some bridge."

"You're a fine host! Always giving me the bike with the little handlebars!"

"How many times must I tell you, Kiwi, not to gape when the master is cheating at solitaire?"

'Swim for your lives! It's Bosko, the Sword-Swallower!'

"Good Gracious, Matilda!—You, too?"

THE WAGER

"Hey Mama! Willie's back!"

"F'goshsake, Birdie, spit it back! Spit it back!"

"Scram!"

UNSUNG BEASTS WHO HAVE MADE BIG BUSINESS POSSIBLE.
The Models in the Animal Cracker Factory.

"No thanks! Last New Year's I got so plastered I thought I saw a horse!"

"Quit blowing those damn bubbles! You're driving me crazy!"

Cross-eyed Diver—*Gawd! He thinks I'm making fun of him!*

"Ahh—Haaa-a-a! And she said she was going to spend the week-end at her mother's!"

AN UNSUNG HERO IN THE HISTORY OF SPORT

Gus Plodoplud *(who threw in the ball for the first game of polo): Now boys, let's have some action!*

FORGOTTEN EVENTS OF HISTORY
Noah's dissolute brother, Goah, preserves the D.T. beasts of his day for posterity.

FAMOUS INITIATIONS OF HISTORY
Neophytes of Ye Round Table Take the Test Terrible.

"What! Stop the wheel and spoil the Five-Year Plan? No! Let
him ride it out for two more years!"

"It says here, Oh Most Exalted One, that under Technocracy one man shall do the work of many."

"Cripes! And she promised to marry me after the very first thaw!"

Quick, Henry, the Flit!

"Now it's an hypothetical case, I know,—but if you were up to your neck in Flit and someone heaved a brick at your head, . . . would you duck?"

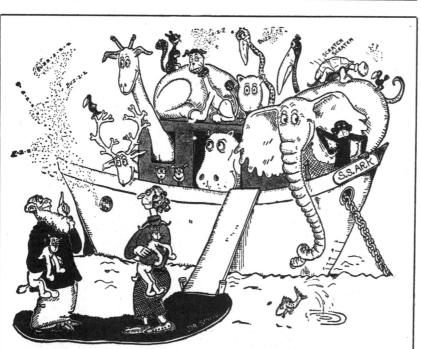

FATHER NOAH: *Look at those fleas! I thought we took only two on board.*
MOTHER NOAH: *We did—fleas are funny that way. But it won't be long now! I'm taking two cans of flit.*

"To be sure it ain't half as much fun as the genuine thing, but

.there ain't no chance

. . . of a dressmaker's dummy . . .

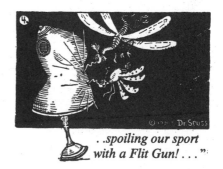

. .spoiling our sport with a Flit Gun! . . ."

137

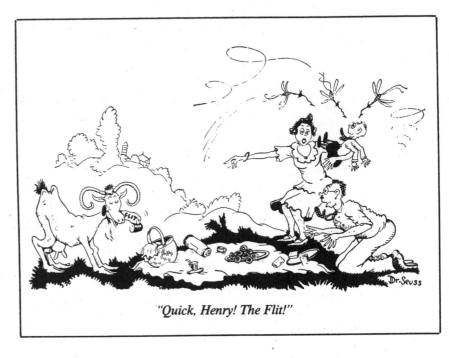

"Quick, Henry! The Flit!"

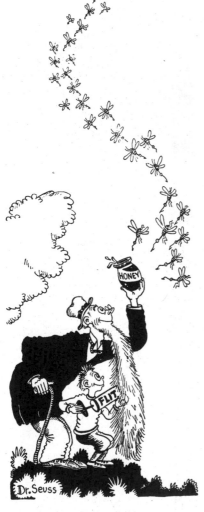

The Ambush

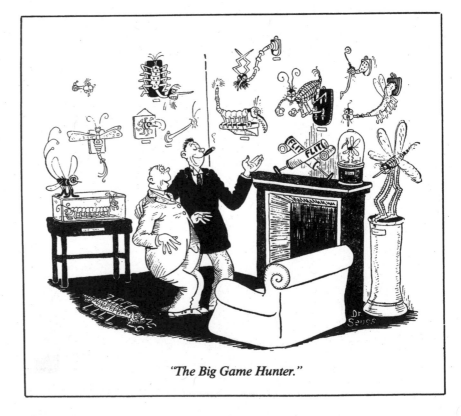

"The Big Game Hunter."

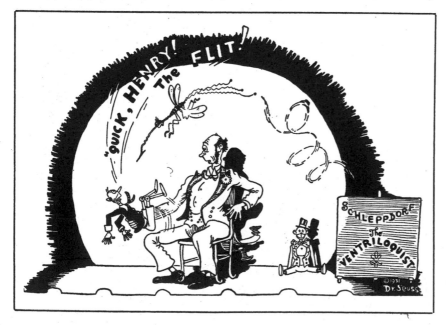

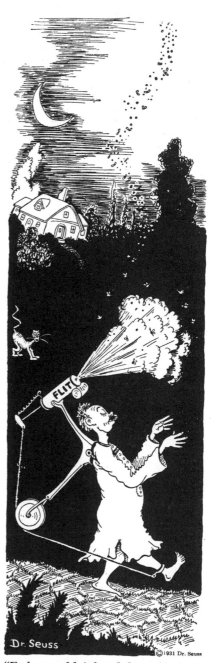

"Father couldn't break himself of walking in his sleep—but he could insure against mosquitoes."

"Quick, Henry! The Flit!

Theatrical Note
After a very unfortunate experience with a mosquito in a New Jersey playhouse, the 5 Strongarm Brothers have enlarged their troupe to the extent of one Flit-gun sharpshooter.

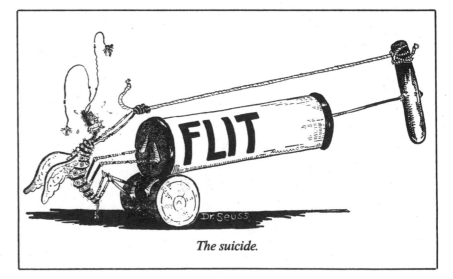

The suicide.

140

NIGHTMARE VICTIM—*Good Gosh! And not a drop of Flit in the house.*

Quick, Henry! The Flit!

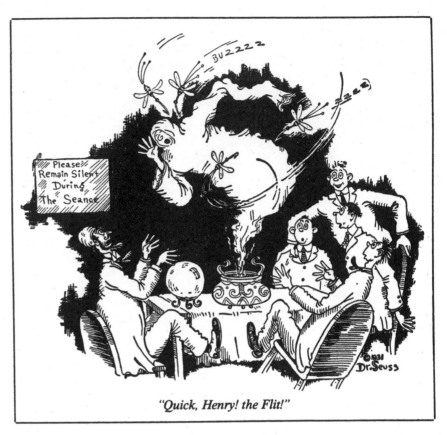

"Quick, Henry! the Flit!"

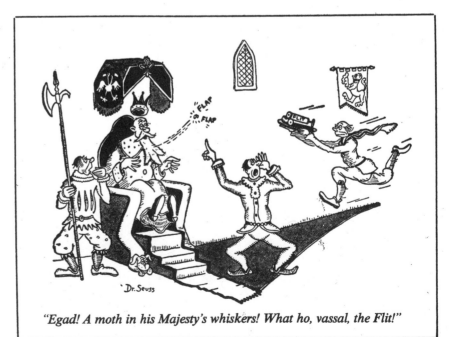

"Egad! A moth in his Majesty's whiskers! What ho, vassal, the Flit!"

An Ancient News Picture

The above photograph was found in recent excavations under the city of Rome. Noted archaeologists say it is from the Sunday Roto Section of Rome Graphic, and appeared in B.C. 1073. The picture depicts that sly satyr Flit undoing the work of the unpleasant goddess Insecta.

". . . For better for worse, for richer for poorer, till Flit do us part—"